Still Life

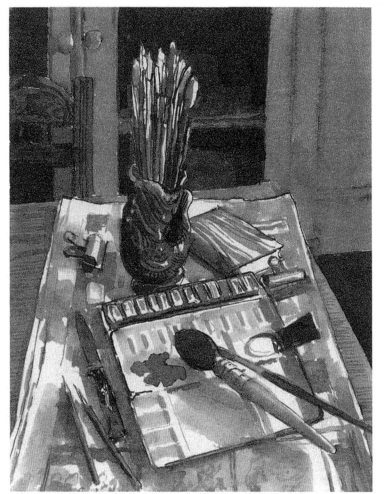

VALERIE WIFFEN

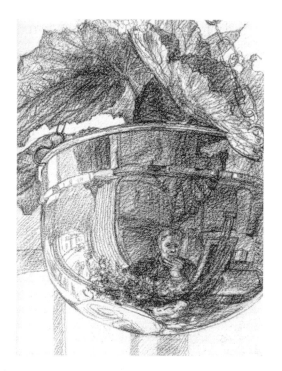

First published in 1999
by HarperCollins*Publishers*
London

© HarperCollins*Publishers* 1999

Produced by Kingfisher Design, London
Editor: Diana Vowles
Art Director: Pedro Prá-Lopez
Designer: Frances Prá-Lopez

Contributing artists:
Gaynor Marsh *(page 6)*
Colin Clarke *(page 8)*
Gay Hodgson *(page 11 top)*
Fred Dubery *(pages 16 bottom, 17 top, 22 top, 23, 54 top, 58)*
Eric Rimmington *(pages 18–19 bottom, 22–3 bottom, 25 top, 30, 33, 54 bottom)*

A catalogue record for this book is available from the British Library

ISBN 978 0 00 793385 3

Printed and bound in China by
RR Donnelley APS

CONTENTS

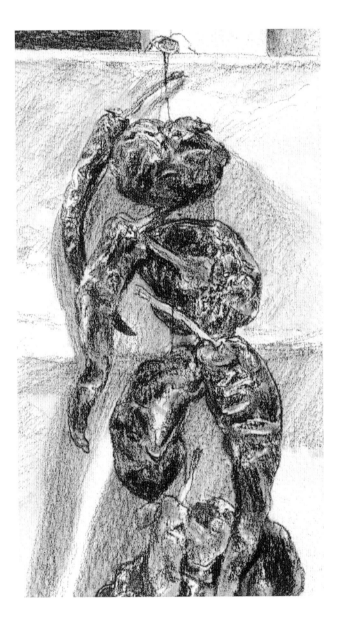

Introduction 4

Tools and Equipment 6

Choosing the Right Medium 14

Selecting your Subject 16

Composition and Scale 20

Light 24

Tone 28

Proportion and Perspective 32

Form and Space 36

Pattern and Texture 40

Specific Surfaces 44

Visual Characteristics 48

Interpretation and Evaluation 54

In Setting 58

Working from Reference 60

Introduction

Learning to draw still life has the charm of economy, since your drawing experiences can take place on your table top. Better still, if you are a beginner you will be introduced to all the drawing challenges that you will encounter in other subjects, and be given the opportunity to develop methods to cope with them before you branch out. For example, drawing your cereal packet convincingly will pave the way for drawing the same rectangular form as a tower block in a townscape, and your favourite pot plant has the same basic structure as shrubs and trees in a landscape. Once you have developed drawing skills they will be transferable, because you will have learned to look. Careful observation is the cornerstone of still life drawing, and the habit of looking for evidence to inform each mark will give you a flying start.

Drawing is a practical task first and foremost, so you need to prepare yourself in practical terms so that you can succeed. Take a moment before you begin, and check that you are going about the process in the soundest possible way. First, choose whether you will stand or sit to draw. Sitting is fine if you have no easel or cannot stand for long, but standing has the advantage that you will be able to move back from your work easily.

This is important, because drawing calls for frequent assessment as each new mark or stroke is added to build up an image. Checking additions from a drawing distance is only partially successful, because you are immersed in details and have a fragmentary view. An overview is needed to compare the drawing and subject properly to see how they match. This is achieved by standing back to a point where you can see both together, and running your eye quickly between them. If you are sitting, simply get up frequently to do the job – ideally every two to three minutes!

After observing well, standing back regularly is the most important thing you can do to raise the quality of your drawing. You will see problems

as they emerge so you can nip them in the bud before they become entrenched, and you will be able to evaluate correctly and adjust accurately so that you get better results faster.

Always fix your paper to a board or use a rigid pad, so that you can get the paper at the right working angle. If you are not using an easel, raise your working surface to a slope. This avoids the distortions that occur when working flat, caused by a tendency to draw too large at the top of the sheet because it is further away,

making the image look smaller. If you are sitting at a table, pull your chair back and rest the bottom of your board on your lap to keep your drawing at an even distance. This will help you to avoid hunching over and causing backache, too!

You see clearly at the centre of a narrow cone of vision, and less sharply with peripheral vision beyond it. Position your drawing surface at the edge of your clear vision. You will be holding scraps of visual information from your observations in your memory until you can make the mark to represent them. The extra time it takes to turn your head back through a wide angle from looking to drawing is quite enough for you to lose the thread. By keeping your image as near as possible to your still life, evaluation as you look and draw is easier too, and each new mark can be checked at once to make sure it meets your requirements.

Finally, place yourself correctly. If you are right-handed, look past the left side of your drawing to see your subject; if left-handed, look past the right side, so that you avoid reaching awkwardly across your body to draw.

Now you are ready, begin by finding a straightforward element you can capture accurately and easily, without any other reference points to help. Anything you can draw in isolation will do, but avoid difficult curves as a beginning. Look for an easy angle or simple form, perhaps a shadow edge or a convenient geometric shape. Once you have drawn it and made any necessary adjustments, you have made your start. Happy drawing!

Valerie Wiffen

Tools and Equipment

Visiting an art supplier can easily trigger a buying spree, but impulse purchases often prove unnecessary. Build on small selections of basic media, and add new items and extra colours gradually as your needs justify them. Always buy the best quality your budget will allow, because hues, consistency and permanence are often disappointing in cheaper ranges.

Pencils

Familiar 'lead' pencils, with a core of baked graphite and clay, have the advantages of versatility, economy and portability. They are graded 'H' for hard, 'F' for fine and 'B' for black. H pencils, with more clay content, are for technical drawing and their marks are pale and inflexible, so graphite-rich B grades are best for artwork. The higher the number, the softer and more quickly blunted the 'lead' and the blacker and more easily smudged the drawing. F grade pencils have the blackness of B grade but a much firmer 'lead'.

A well-sharpened pencil is an expressive tool, shown here depicting the fineness of a feather, but remember that a pointed instrument making linear marks accumulates depth and impact comparatively slowly.

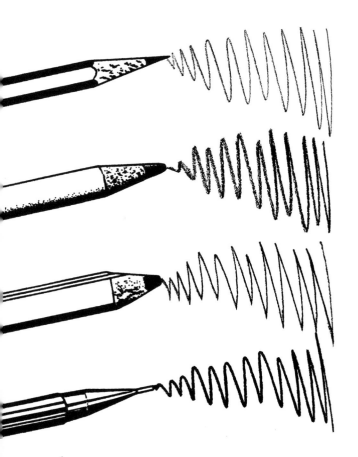

When buying, choose good-quality pencils with clearly differentiated grades, or graded drawing leads for your clutch or propelling pencil. Start with a 2B or an F. When mixing grades, notice that the blacker dominate, so keep the range narrow. As short points are soon blunt, use a sharp knife to give pencils a long, tapering point. Erase with a plastic rubber. Soft grades require a light spray with fixative to prevent smudging.

Graphite sticks, graded like pencils, are simply fat 'leads' without casings. Used broadly, they create broken texture and also cover faster.

Water-soluble graphite pencils, applied dry and washed afterwards, spread their marks widely. The softest grades dilute most easily, but try effects on scrap paper first to see the strength of the washes that different dilutions produce.

Pens

Dip pens are penholders with detachable nibs, to be dipped by hand into ink or liquid watercolour. Traditional flexible cut steel drawing nibs with long points are best, as changing your drawing pressure makes for varied, expressive work. Dye-based coloured drawing inks fade quickly; choose water-soluble inks made from traditional formulas, which tend to be more permanent.

Reed and **bamboo pens** are available from good art suppliers. The delicate reed and robust bamboo nibs are rigid but the tips can be used from widely differing angles, giving an enormous variety of marks.

Technical pens are easy to carry and quick to use. They are mechanical devices with tubular nibs, designed to produce even lines in set widths, so use ingenuity to create interest from their inflexible marks. Refillable types will save money long-term, but select ones that are easily cleaned.

Writing pens, including fountain pens, felt-tipped pens and ballpoints, may be handy, but they are inflexible and their inks are often fugitive. If you enjoy them, use them for short-term projects only.

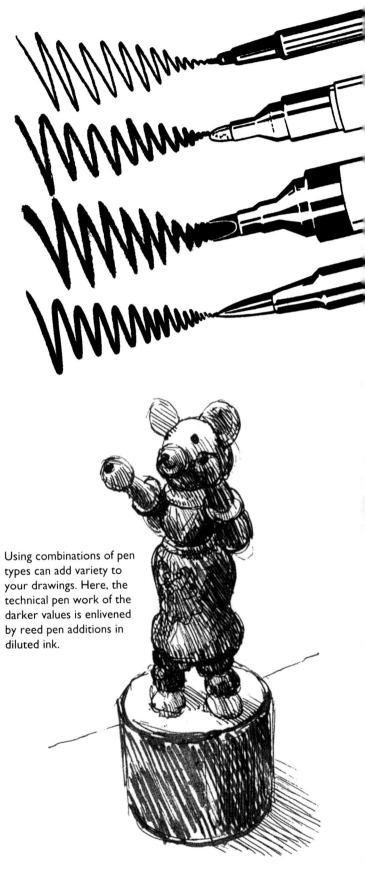

Using combinations of pen types can add variety to your drawings. Here, the technical pen work of the darker values is enlivened by reed pen additions in diluted ink.

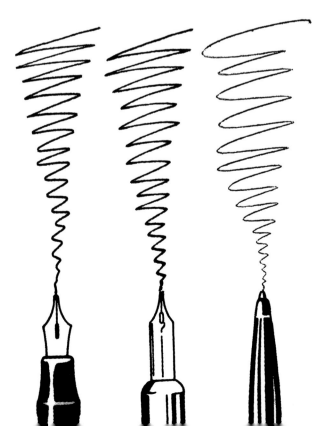

Soft pastels will capture tonal extremes with great speed if used broadly, and details can be added as time allows.

Artist's Tip

All coloured media in stick form can be physically mixed on the paper surface or optically mixed by making adjacent marks with different colours, which will be perceived as a blend at a distance. Stumps of compressed paper blend dusty media accurately too.

Pastels, chalks and crayons

Hard pastels, also called carré pastels, artist's chalks or crayons, are lightly baked combinations of pigment, binder and clay for firmness. They are usually square-sectioned and make beautiful, crisp marks, but leave traces if erased. These are broad-tipped media, so as the edges become worn turn them round to obtain finer lines. Traditional earth-coloured ranges are the most durable. Pastel pencil cores are a similar formula, and combine well for delicate work.

Soft pastels are pigment lightly bound with gum, pure in the middle of shade ranges, with white or black added to make paler or darker tones respectively. They are dusty and are erased with a kneadable putty rubber. They must be fixed with fixative spray, but as their opalescent beauty is the result of light reflected from the dust particles, too much fixative soon dulls them. Overworking and complicated colour blending also produce muddy effects, so keep handling fresh and mixtures simple.

Oil pastels and **wax crayons** are dense enough to be scratched and scraped through. If you are working on stretched paper (see page 10) sealed with gum or size, they can be thinned or even removed altogether with turpentine or white spirit. They require the use of oil pastel fixative to avoid smudging.

Charcoal and carbon

Allowing willow or olive twigs to smoulder in reduced oxygen conditions leaves only the soft carbon material called charcoal, an ancient medium. Modern variations include compressed charcoal and charcoal pencils. All are erased or partially removed with a putty rubber, and require fixing to prevent smudging.

Charcoal sticks are sold in packs or bundles graded hard, medium or soft, and sized from extra large (called scene painters) to fine. All provide a rapid, easy-to-remove, dusty cover in a range of shades from dark grey to brownish and full black.

Compressed charcoal is sold in pastel form. Concentrations of burnt, sooty elements make slightly oily, dense marks of great richness but they are only partially removable. Graded grey tones cut with chalk are also available.

Charcoal pencils with processed charcoal cores and smoother, hard carbon pencils are either grouped broadly like stick charcoal or graded like graphite. They have the advantage that their richer tonality adds impact to pencil techniques.

Using the sides of a charcoal stick as well as the tip gives rapid cover that is easily removed if necessary. Knead your putty rubber to a point to pick out details.

Brushes and wet media

For wet work, stretch your paper on an unvarnished board to prevent buckling as the damp paper relaxes. Cut four pieces of brown, water-based gummed tape longer than each side before lightly sponging the paper. Pull the tape under your finger on the sponge to moisten it and stick each piece down in turn, half on the wood, half on the paper. The paper will dry flat, and will remain so while secured. When removing it, slit sideways carefully under it.

Brushes are long-lasting if their quality is good, so build a collection. Try nylon first; big sizes will point well for detail or spread moderate washes. Consider Oriental alternatives to beautiful but expensive sable and squirrel. Brown weasel, which has a spring when wet, is for details and limp, white goat hair makes a mop brush for flooding broad areas with wash.

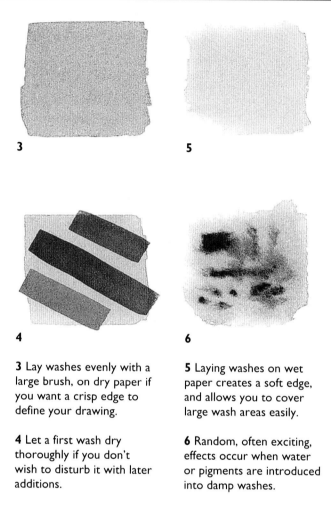

3 Lay washes evenly with a large brush, on dry paper if you want a crisp edge to define your drawing.

4 Let a first wash dry thoroughly if you don't wish to disturb it with later additions.

5 Laying washes on wet paper creates a soft edge, and allows you to cover large wash areas easily.

6 Random, often exciting, effects occur when water or pigments are introduced into damp washes.

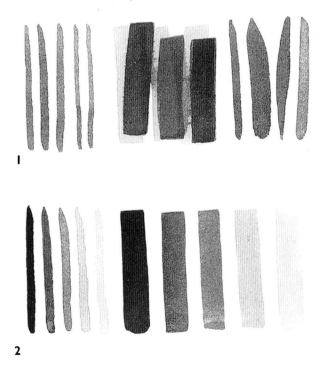

1 *From left to right:* small detail, flat and large pointed brushes offer a range of quite different characteristic strokes and covering power.

2 Try wash strengths on scrap paper, varying pigment dilutions to make progressive increases or reductions of tone as shown here.

Watercolours are finely ground pigments which sink into the paper, colouring it permanently. The best are expensive, but have great staining power and make strong, brilliant washes. For large-scale work, buy tubes or concentrated liquid forms. For small drawings, half pans containing solid paint are durable, but making any quantity of wash is laborious. If you can afford them, large pans will enable you to be more versatile.

Watercolours combine well with water-soluble coloured pencils, which, unlike graphite pencils, dissolve rather than showing through washes. They can be erased while dry, before they have been washed over. If you draw onto wet paper, they are vivid and fixed immediately. Oil pastels and wax crayons are useful for resist techniques; the washes roll off the grease or wax, colouring only bare paper.

Gouache is opaque, water-based paint with a flat, matt finish. The best-quality paint is sold as designer's tubes, with poster paint in jars and cakes of opaque watercolour the poor cousins. The covering power of gouache is a great advantage, offering second chances to retrieve unsatisfactory work, provided you apply dense enough coats and refrain from over-brushing, which stirs up underlying colour.

Acrylic paint is a water-based medium, often used to produce a picture surface retaining brush strokes or impasto, as oil paint does, but drying rapidly. You will need similar equipment to an oil painter's if you choose thick paint in tubes. For coloured drawings, consider the bottled liquid versions, which have good covering power and are easier to mix and dilute to washes.

Water-soluble ink, premixed to the right strength, creates a full range of tones and can be applied rapidly by brush to capture complicated subjects fast.

Dry media such as chalk and pastel can be either overlaid with a wash or applied on top of a wash.

Ink washes applied with a brush create wide and diverse tones quickly and easily. Use non-waterproof ink for preference; the varnish content in waterproof ink curdles when diluted and causes brush hairs to shed if it is not washed out completely. Water-soluble ink can be disturbed and the beautiful effects marred by excessive washes, so ration applications.

Newsprint paper, although cheap, is extremely perishable. Use it for your briefest trial sketches only.

Tracing paper helps when considering alternative arrangements. Try a move out on a tracing overlay first.

Stationery paper has size limitations, but the content is surprisingly sound. It is useful for small roughs.

Cartridge paper is a term used to describe lightweight, smooth paper. It is acidic unless otherwise stated.

Surfaces to draw on

Paper made from wood is acidic, and unless the acid has been neutralized the paper will become yellow and brittle, as happens rapidly in newsprint, for example. You should only use acidic paper for short-term projects.

Watercolour paper, whether it is hand-made sheets from traditional mills, mechanical mould-made paper or the cheapest machine-made paper found in large rolls, is always acid-free, being made from cotton fibres. Three surfaces are available: 'Hot-pressed' paper is smooth, and suitable for fine work such as pen drawing; 'Not', or cold-pressed, has a slight texture or 'tooth,' and holds dusty media well; and 'Rough,' with a heavy texture, shows washes to advantage.

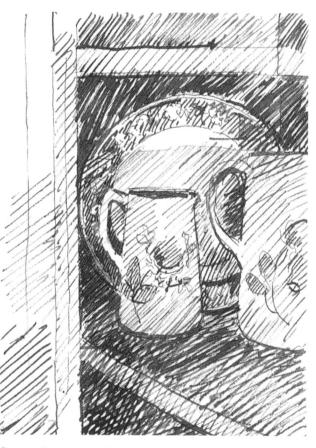

Pen work is easy on the smooth surface of hot-pressed paper, while mixing pen types and ink colours will give pen drawing extra scope.

Coloured Ingres and textured pastel papers provide a toned ground for colour work, but are often acidic.

Watercolour paper is sold in various weights, and the lighter, smoother types are economical for drawing.

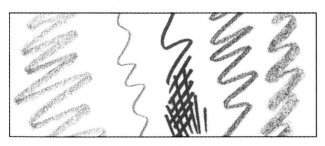

Bristol and other acidic illustration boards have prepared surfaces, making them receptive to pen work.

Layout paper is smooth and light. It is for trying out format and design options before you begin work.

Let the paper surface do the work by drawing rough objects on rough watercolour paper.

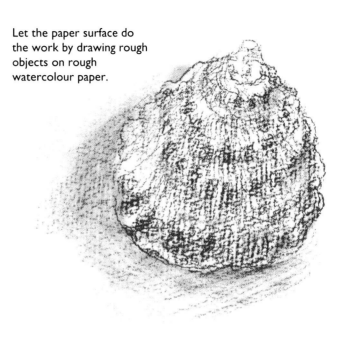

Cartridge paper is available in acid-free form, and the nearly smooth surface is suitable for many media. In its untreated, acidic form it is the paper available in most sketchbooks, where it is useful for the jottings and brief notes you will want to make when you are out and about for which longevity is not an issue.

Bristol board has a surface specially prepared for fine work in pen and ink. As with other surfaced design boards, in smaller sections it is rigid enough to use without a drawing board when you are on location.

Typing paper, **photocopying** and **layout paper** have a hard surface finish and are too thin, bland and smooth to provide an interesting drawing surface. However, cheapness and availability make them useful for trying innovative approaches and practising new techniques without worrying about the cost.

Tracing paper is semi-opaque. If you are exploring various possibilities in a drawing, it enables you to try out alterations by sketching them on tracing paper and laying them over the work to assess the effect before you change your original.

Choosing the Right Medium

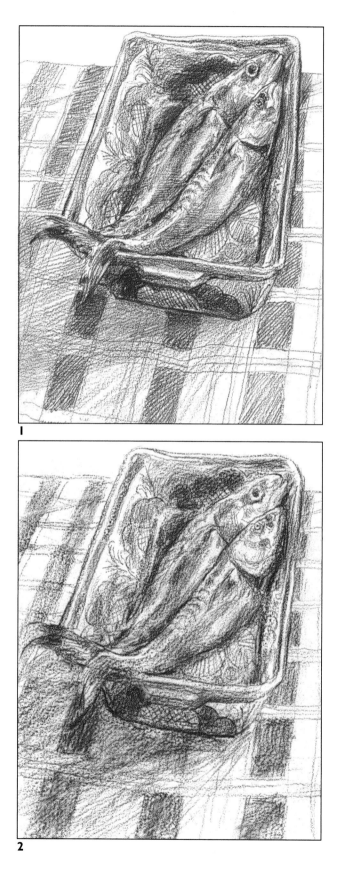

1

2

All the drawings shown are studies of the same fishy dish, but the time spent making them, the media and the paper surfaces involved are very different. Consider your choices carefully; the time available and your interpretative intentions will influence your media selection. For example, you may feel most comfortable with pencil, but if you have only moments to capture a vision, speedy charcoal will be a better choice. If you want to make a detailed, descriptive study, sensitive pen drawing will suit your purpose better than blunt charcoal.

Scale is important, too. You will struggle to make fine marks with oil pastels, which work well large-scale, but a big drawing in fine pencil shading will take an age to finish. In general, fine media that make linear marks are suitable for slower-paced or smaller work. Coarse media that make wider marks or can be turned to use a broad face are good for covering large areas or working fast, as are large brushes, which can make a broader mark, and offer the fastest cover of all.

Media behave differently on different surfaces, and inappropriate matches make uphill work of the drawing. For example, fine media are best on smooth or lightly textured papers with a firm finish, because hard points can raise the surface on softer papers and will skid across the texture of rough ones. However, a moderate texture is needed to hold dusty media, and a strong 'tooth' is just the thing to show watercolour washes to brilliant advantage. Look out for samples and art shop sales to try different alternatives and identify good combinations, so that you are free to choose the media that suits your time and purpose best.

1 2B pencil on Not surfaced watercolour paper.
2 Charcoal on Not surfaced watercolour paper.
3 Pen and ink on Hot-pressed paper.

4 Brush drawing in wash on Rough watercolour paper.
5 Soft pastels on toned, textured pastel paper.
6 Hard, greasy chalk on Not surfaced watercolour paper.

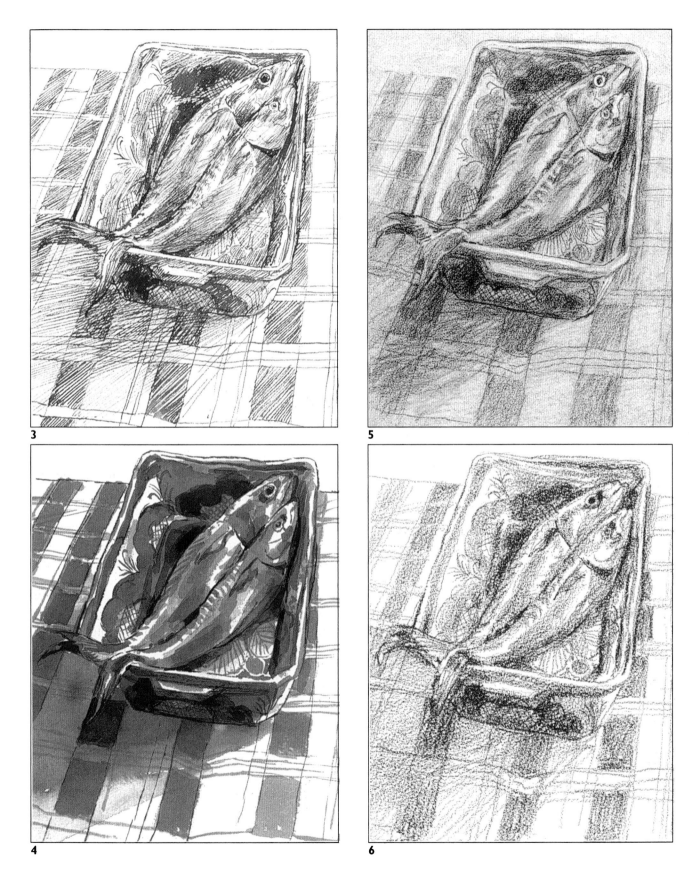

3

5

4

6

Selecting your Subject

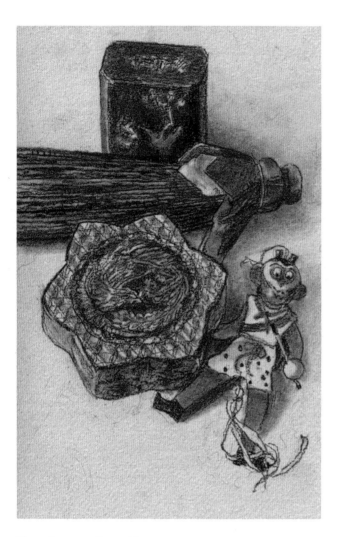

The best choice of subject is that which you feel most involved with and compelled to draw. Unless your interest is caught no amount of skill or effort will spark off excitement, and your work will be lack-lustre. Start with objects you know well or use often, as they have a familiarity gained from regular observation and will give you a flying start. Take care to choose colours you like, even if you are working in monotone. You will be gazing at the group for a while and dowdy colours or monotonous tones will soon blunt your appetite for the drawing.

Themes from real life

At home, the paraphernalia of your activities or interests will provide you with a wealth of individual subject matter. Each room from kitchen to attic will supply a selection of ready-made groups, waiting to be drawn. Often these need little rearrangement, having the charm of spontaneity. Alternatively, compose a new group from a favourite collection such as bric-a-brac, or watch out for items left in an interesting sprawl after use. Drawing a child's playthings, the sewing machine or a toolbox will fix a particular period and pastime in your memory. By drawing objects with emotional links, you will be more involved and able to persevere, making better progress with your drawing.

Many themes will provide links to give coherence to your selection. Here the Oriental origin of the objects is the thread that binds them, but they are further united by their overlapped placing, which creates a strong two-dimensional group shape (*above*).

A new guise for a familiar corner may prompt you to record it. Decking the mantelpiece with festive greenery adds asymmetrical natural forms to the regularity of the architectural elements, increasing visual appeal (*right*).

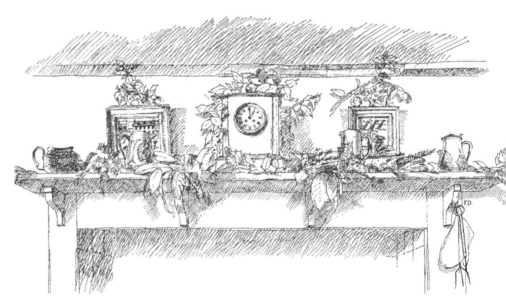

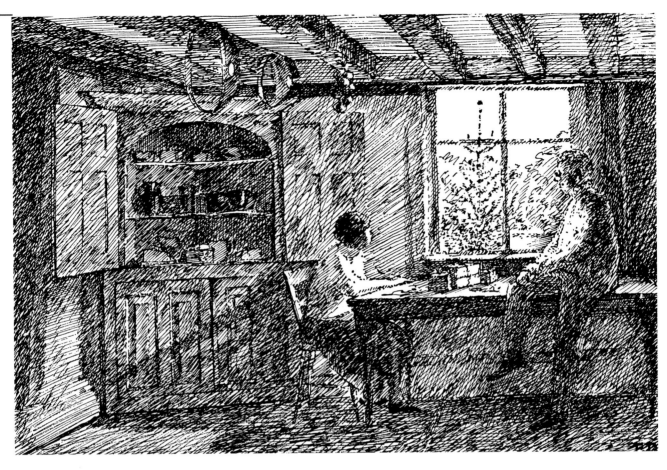

Drawing a broad span to include several small groups around the room gives distinctive characteristics, such as comfort and tranquillity (*above*).

Focusing on a small area in intimate detail can make a decorative representation of everyday objects in a familiar place (*right*).

Forming a group

Certain groups may appeal to you because they convey a particular atmosphere redolent of home or feature well-loved objects, but combining the right elements in your still life is a key skill in selecting your subject. Notice that the way you group the objects together changes the impact they make. This is because a first glance will encompass the overall shape of the combination. Generally, spacious, wide, horizontal subjects are stable, while tightly packed, angular or upright groupings are lively and dynamic. Be sure to include sufficient variety in the group shape. For example, long, low arrangements will benefit from the addition of one or two taller items to lend height and horizontal objects will help tall groups.

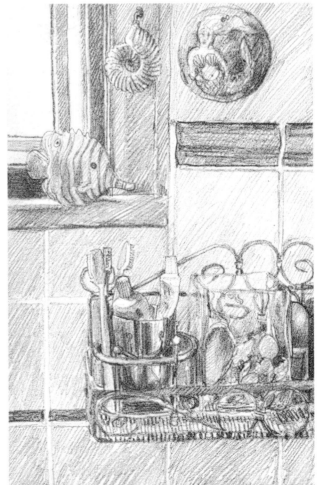

Choosing for contrast

While your personal preferences may be for polished surfaces or matt, rough textures, for round shapes or straight, angular forms, a subject comprising too many of the same elements will be the visual equivalent of cabbage soup, followed by stuffed cabbage leaves and cabbage salad. A contrast is pleasing to the eye, so be sure to include something of the opposite to the main characteristics. Varying forms, tones, textures and surfaces to include some foils for the major elements will ensure that monotony is avoided.

Unconventional choices

Even if you are a traditionalist, reserve the right to decide on the format, scale and medium best suited to each unique combination forming your choice of subject. Excellent drawings can result from unconventional and stimulating choices, and making your own still life selections involves pleasing no one but you. Follow your inclinations and consider your options carefully. You may tailor your selection to a long, narrow rectangular shape or one nearly square, or

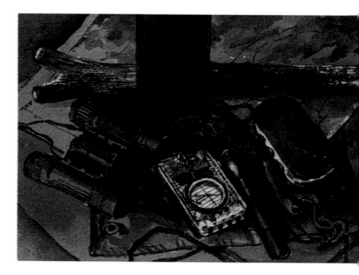

Hiking equipment includes varied textures and surfaces, patterned and plain objects, and a drink bottle for height.

choose items that lend themselves to a strongly tonal or fine and delicate rendition, or an oversize or miniature representation. Varying the lighting or surroundings, adding or taking away objects and making several thumbnail sketches of possibilities will all help you to make decisions about selection.

Linear arrangements make drawings readable, like lines of verse, while negative spaces between items are crucial in determining the group shape. Omitting period evidence such as electricity sockets conveys timelessness, and charcoal, as old as humanity, adds to the illusion.

You can select by cutting items with the picture edge, drawing only portions within the frame. Here, the toolbox makes further diagonal cuts, and the bird's eye viewpoint creates a strong, grid-like lay out, helping to organize a complex choice.

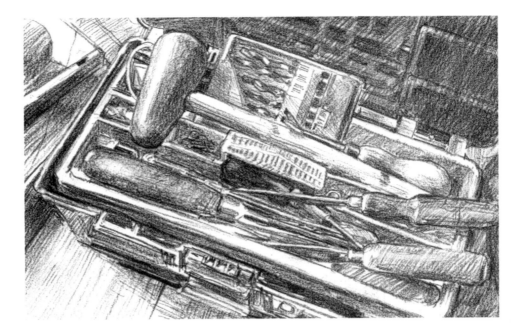

Visual selection

Trying to edit out something that is in view is difficult, obliging you to ignore objects or elements and imagine what you would have seen in their place. Making sure that you are happy to draw everything in frame is a better idea, and a brief examination of your potential choice will soon reveal anything you are unable or unwilling to tackle. Remove any offending items, move the other objects to hide them, or simply reselect your viewpoint so that they are excluded.

Artist's Tip

Make selections which are just difficult enough to extend you, but not so complicated that a successful drawing is out of reach. You need a reasonable challenge, not a hopelessly difficult task, in order to maintain your interest and enthusiasm.

Composition and Scale

Make preliminary sketches to decide the format of your composition, as the obvious choice is not always the best. Having examined the alternatives, you will be able to choose between landscape (horizontal) and portrait (vertical) formats and determine the best proportions for your view. A drawing needs to be composed, just like a good letter or song, with an eye to the overall effect. The visual directions are both two- and three-dimensional, moving across and through the illusory picture space you are creating, but should return to the centre of interest you have devised. For practice at calling the attention of the viewer, set up groups to follow successful composition types, offering a clear position for your central focus.

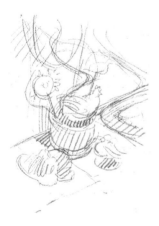

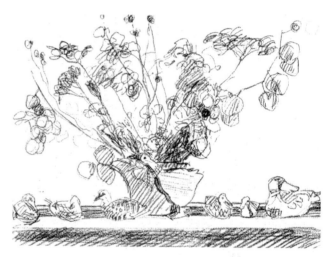

I A simple L-shaped or reversed L composition is easily managed. Any upright and horizontal combination such as a window frame provides a right angle.

2 The two arms of the dark L shape lead the viewer's eye right to the centre of the angle, where interest is centred on more detailed work.

Find alignments via rough sketches (*right*), such as the semicircular direction through the foliage here, above a triangle composition centred on the goose.

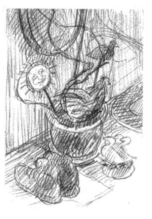

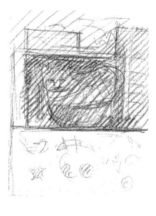

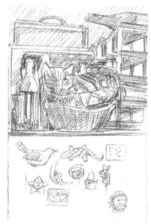

I Curvilinear compositions are dynamic; rough sketches incorporating any straight or angular elements will help you gauge tricky curves.

2 Contrasted with the straight, angular elements around them, the sinuous compositional movements are easier to see.

I Rectilinear compositions need not be dull; well proportioned and with curved contrast, they will plausibly convey depth.

2 Tonal contrasts and the different visual stopping points provided by objects on a surface add interest to a square-based composition.

Deciding on scale

Your next choice concerns the scale of your representation. Drawing sight size, or the size you see, is always the easiest option as the process is a simple one, relating the marks you draw directly to the perceived scale of your subject. Larger or smaller works made from the same spot involve changing the scale of each individual mark consistently, and the more complex process confuses beginners. A safer alternative is to relate the scale to your position, so that to draw a subject on a grand scale you sit extremely close to it. Making smaller drawings allows you to place yourself further away, unless you are making a highly detailed rendition, or your eyesight dictates otherwise.

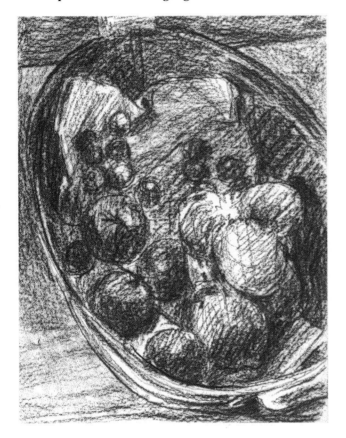

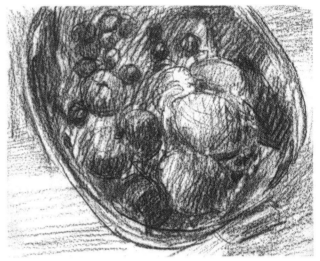

Reducing the size and format to landscape (G) and truncating the image alters both the composition and perception of scale, with the tub a mere perimeter for the smaller contents (*above*).

Full-scale portrait format (F) has a monumental quality, allowing the viewer to become aware of the tub's depth and size, whose contents are incidental compared to the vast container (*above*).

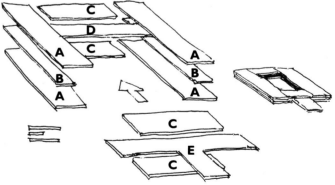

Make a viewfinder to help you determine composition and scale with 12 card strips, glued together as shown, Bs between As and D and E between Cs. Glue the Bs so that one edge is level with the edges of the As, thus leaving the other edge recessed between the As.

Form three sides of a square by gluing D's protruding width into the recesses. The fourth side runs freely in the recesses to vary formats. Hold the mask close to your eye for a comprehensive view and further away to select just a portion of it (*right*).

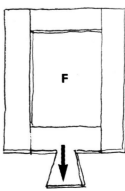

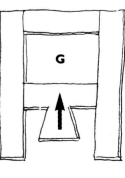

Composing the image

Your viewfinder helps you to choose how much or how little to include, but your creative intention is an important compositional factor. Opting for a wide span tackling everything in view or a small group in a quiet niche can create completely different images. Examine the possibilities carefully, weighing the charms of intimacy against the grandeur of a broad vista: which is preferable on this occasion? Your subject may lend itself to massive, simple treatment, or a decorative exploration of a wealth of detail, and you will have personal preferences about the kind of composition you favour. Remember to ring the changes as much as possible. Using habitual compositions of a familiar size will become stale however much you prefer a particular approach, and ultimately you could become set in your chosen scale, losing the ability to make a flexible choice.

The shape of the table top makes a solid anchor for the supporting details of tone and texture in this light and delicate garden composition (*right*).

Artist's Tip

Western artists tend to compose with a possibly unconscious awareness of the Golden Section, a mathematical formula concerning proportion. A focal point in composition is roughly the line that divides a perfect square from the rectangle. Consider alternatives, for example composing from central points.

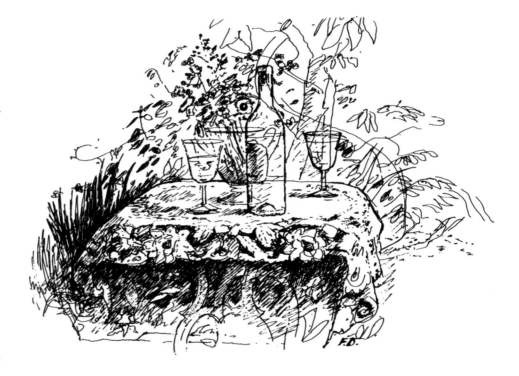

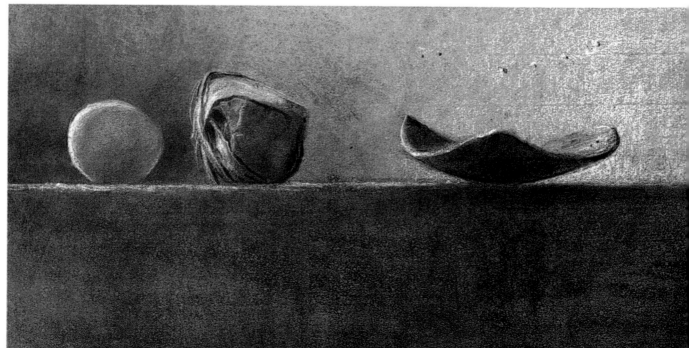

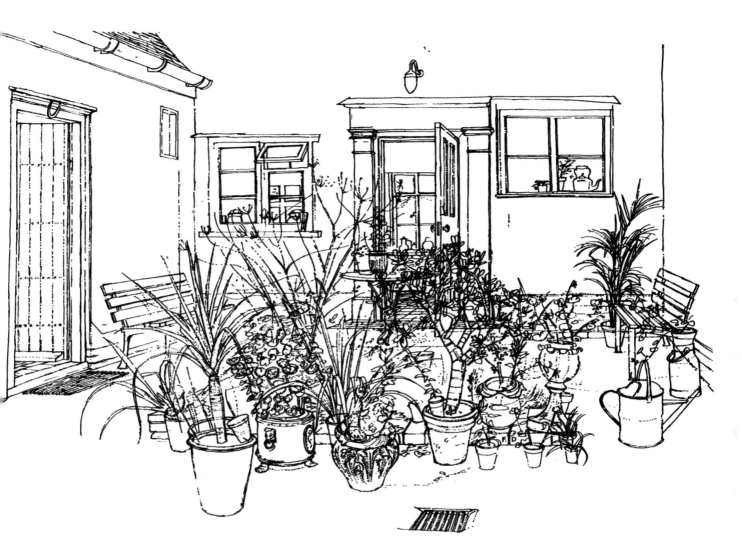

Fine pen lines encompass the whole sweep of a patio with a central pyramid of plants against the rectilinear façade beyond, drawn on a moderate scale (*above*).

Here, a daring composition places the horizontal division centrally, but achieves the visual interest of asymmetry by siting the majority of the subject group left of centre (*left*).

Choosing your scale

A hallmark of good drawing is that the size is immaterial, but the size of your image will influence how it is viewed. Small drawings will be looked at from close quarters, while oversize works must be seen from a sufficient distance to take them in at once, possibly several paces back. Bear this in mind when choosing your scale, and remember that broad areas take time to cover and require large walls if drawings are to be displayed, while tiny works have less impact and may be taxing to make, as every small mark has large implications. Small scales can be cramping too; try a size that gives you room to manoeuvre.

Light

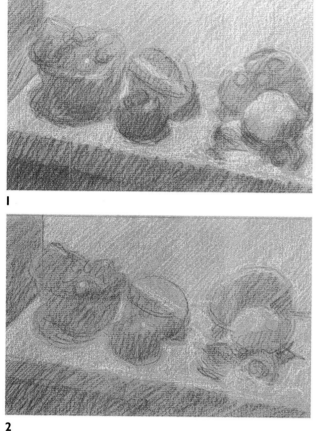

1

Bluish natural daylight is always beautiful, but low winter light levels will shorten your working day. Training alternative lighting onto your drawing means you will be able to work from dimly lit objects, or you can train it onto your subject, which may look best in strong directional lighting with the marked contrasts of heavy cast shadow. Experiment with lighting options, which offer different visual qualities and colours of light; traditional light bulbs, for example, create a yellow bias and a softer sparkle than do brilliant white halogen spotlights.

2

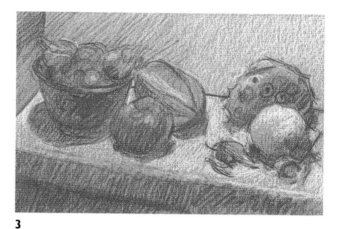

3

1 Using chalk and charcoal on coloured paper establishes lights and darks quickly, while leaving blank paper for medium tones.

2 If adjustments are needed, erase the excess chalk or charcoal dust first with a putty rubber.

3 Make any further alterations before achieving full strength and brilliance.

Artist's Tip

If you have a choice, avoid working under strip lights; they cast light in many directions and diffuse useful shadows.

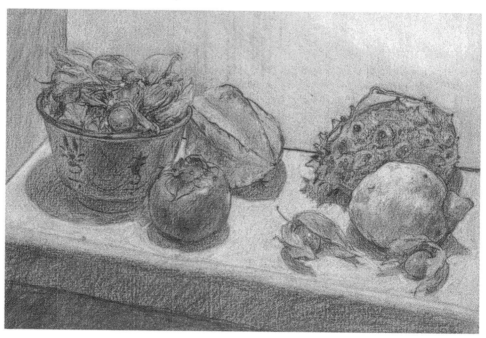

4 Descriptive details revealed by the fall of light across the surfaces of the objects can be introduced safely, because the established framework ensures correct placing.

Choosing light effects

A cardinal advantage of still-life work is that you probably live with many of the items you will use as subjects and see them daily. By observing them under different lighting conditions, you will be able to decide which effects show them to best advantage, or make them easier to draw. For example, a fussy group with too much pattern or detail will be simplified by the loss of many complications in shadow. Low lighting narrows tonal differences, which will conceal the shortcomings of mundane objects, while spotlighting will lend highlights or a brilliant glow to a chosen item, or reveal it against contrasting heavy shadow. Experiment with the placing if you are using additional directional lighting. Many different effects are possible, with top-lighting making pools of cast shadow, a raking light picking out surface detail, and under-lighting creating strange and theatrical effects.

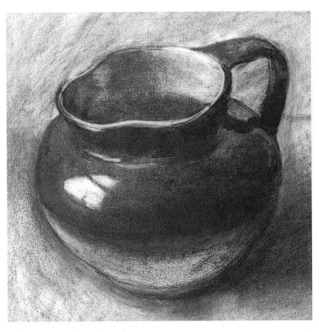

A single, well-proportioned item, lit simply to show off the form, produces an effect of timeless beauty in which the light is the star performer (*above*).

Dealing with changing light

When you are using natural daylight as a source, notice that it changes according to the weather and the time of day. In mixed weather, with sunlight and shade alternating, or on stormy days when light can be tinged yellow or even orange by the approaching downpour, its appearance changes by the minute. Over a sustained period, items in full light at midday may be in gloom by teatime.

Changing conditions can be dealt with by working on a series of drawings rather than one alone, with consecutive works for slower changes or multiple versions for rapid ones. This will mean chopping and changing as sun and shadow chase each other, or perhaps waiting for weeks or months until another impending cloudburst brings storm light around again. The reward for your versatility will be a record of beautiful light effects.

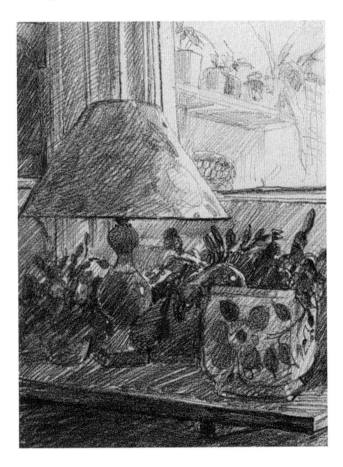

Lost in shadow, the arbitrary view of a window and shelf is unified, and the suppression of distracting detail allows the simpler forms to dominate (*left*).

Choosing lighting by location

Your position in relation to the light source governs the way you see your subject. With the group viewed against the light, placed between you and a window or lamp, shadow will obscure much of the colour and detail, and dramatic qualities will prevail. With the light behind you, the surfaces of objects will be fully lit and reveal full colour brilliance with comparatively little shadow. A side view with directional light, either natural or artificial, shows the form, and includes a proportion of colour and shadow too.

These peppers directly beneath an overhead light cast dramatic shadows. I stood on a stepladder to get the full effect of the light on their skins (*left*).

Artist's Tip

Remember that the sun moves round gradually, changing your daylight view. This means that shadowed groups become fully lit later and vice versa. Have both a morning and afternoon drawing if you work from the same spot all day.

1 A pilot drawing to explore the qualities available when working with the light behind you shows a sharp, clear view, with the light showing up the decorative checked tablecloth.

I

2 The drawing depicts the tonal values of colours across the surfaces of the fruit, the soft shadows on the underside of the bowl, and the contrasting grid of the cloth.

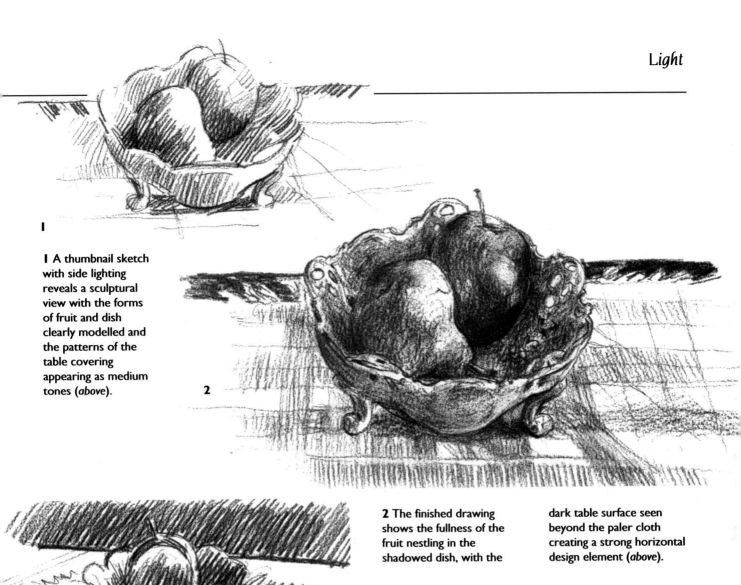

I A thumbnail sketch with side lighting reveals a sculptural view with the forms of fruit and dish clearly modelled and the patterns of the table covering appearing as medium tones (*above*).

2 The finished drawing shows the fullness of the fruit nestling in the shadowed dish, with the dark table surface seen beyond the paler cloth creating a strong horizontal design element (*above*).

I The preliminary drawing made against the light shows a darkly dramatic, simplified view, with the tablecloth imperceptible. The depth of the void beyond is a major factor.

2 The completed drawing derives impact from strong tonal contrasts. The group presents an ovoid shape against diagonals.

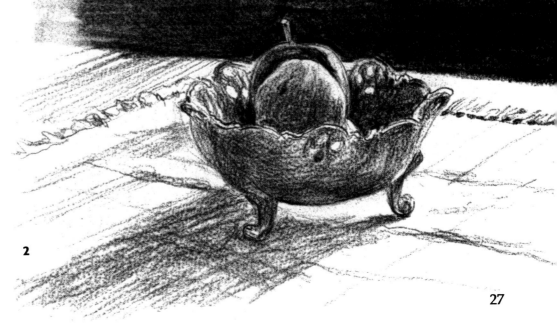

Tone

In drawing, the word 'tone' refers to the depth or brilliance of the shades or colours. When working in monotone you will have to determine tonal values for the colours you see. The easiest way to decide is to half close your eyes and peer through your eyelashes. Their filtering effect masks small, confusing tonal changes and unwanted colour brilliance, showing you the strong shadows as darks, and bright, light areas gleaming. This technique overrides your brain's ability to interpret the values within shadows as brighter than they are.

Remember that paler darks within cast shadows are never as light tonally as the bright values on the lit side of the subject. Correspondingly, no slightly darker elements on the lit surfaces are as strong as the darks of the shadows.

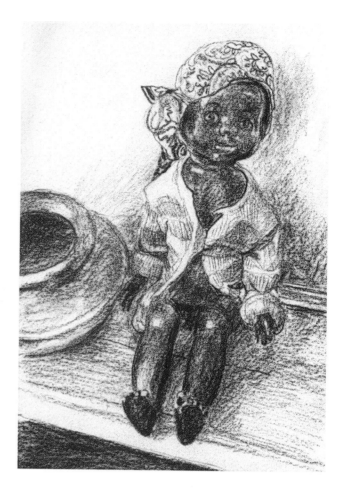

Laying pale tones initially, gradually building strength, and then adding pen lines when you are sure of their places makes complex line and wash drawings easier to handle (below).

By using easily erased charcoal stick until you have finished making adjustments, you can build a basis on which you can then add stronger tones with charcoal pencil (right).

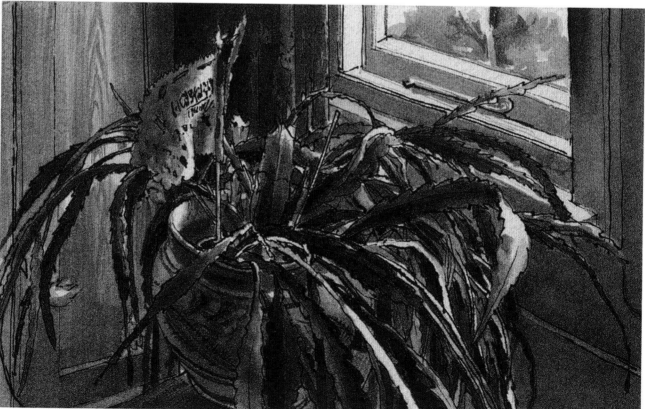

1 With erasable media, you can achieve the best results by blocking tones in broadly to establish the picture.

2 When you have finished making corrections you can reinforce the tones, developing the whole image as comprehensively as possible.

Artist's Tip

Note the richest dark and the brightest light areas on view and keep all other values between these tonal extremes.

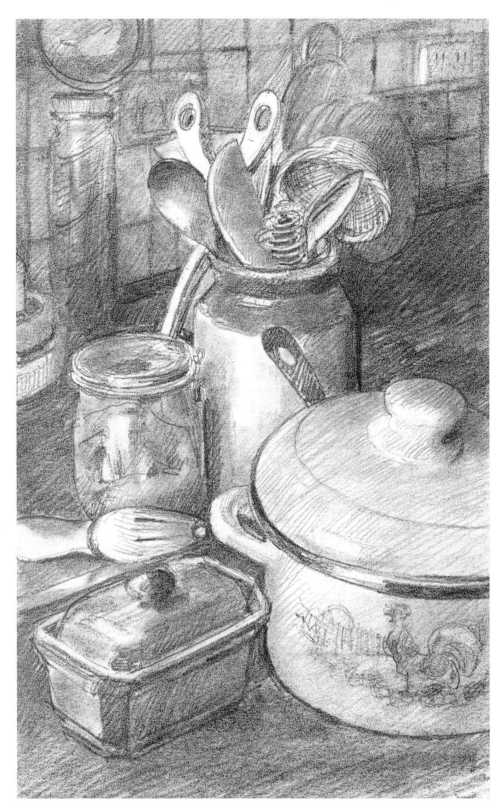

3 Once the positions are satisfactory and the major tonal areas fixed, you can introduce minor tones and smaller transitions until you achieve the required degree of subtlety.

Choosing your mark

Defined simply, the process of drawing from observation of a still life subject is that of devising marks to represent what is seen. Tone is a large proportion of the information conveyed, because the marks darken or lighten the paper. Just like your handwriting, it is the unique nature of your mark making and combining that gives individual style and character. Experiment with your media to see what kind of tonal marks you can make easily – and without discomfort if you draw for a sustained period – then decide which you prefer. You can choose freely because tonal information will describe the three-dimensional nature of what is seen regardless of how the paper is marked, provided the right degree of tonality is in the correct geographical location.

Try a range of methods; for example single line shading or hatching, cross-hatching with second strokes in different directions, or even random textures or dots. Each will depict solidity and light as effectively as graded applications of unbroken tone, provided the right intensity is in the proper place. To check for accuracy, half close your eyes again, and peer at your drawing this time. You should see the same gloomy depths and shining lights in your work as you see when peering at your subject. If there is a mismatch, adjust the values until the drawing corresponds to the view when put to this test, and your tonal scheme will be correct.

A fully toned drawing closely resembles the reality it represents, making it easier to evaluate effects, gauge distances and assess proportions.

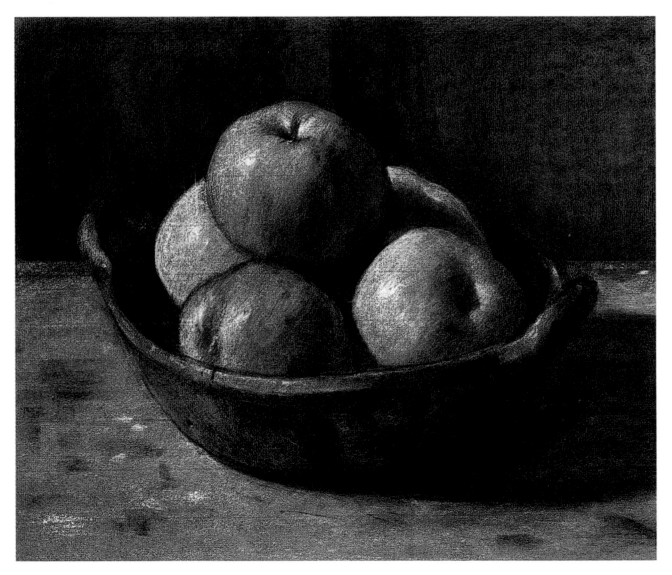

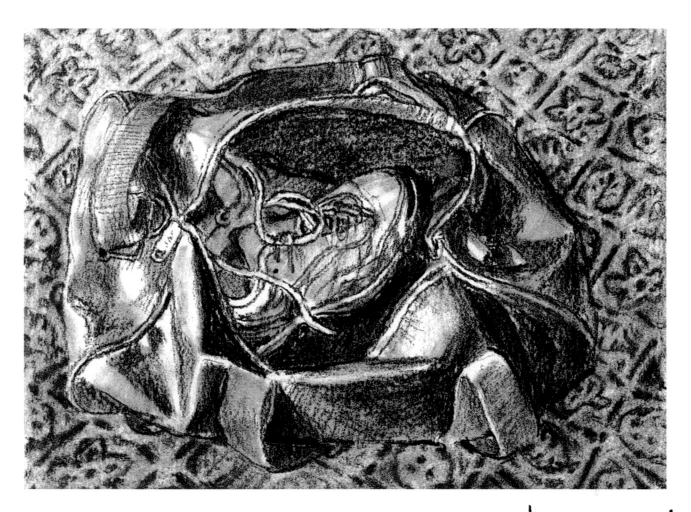

Drawing in colour

Coloured media are a refreshing change from black. Reds and browns have traditionally been used for monotone drawing because they are dark tonally and register well from a distance. If you choose a different colour, remember that very bright shades can distract the viewer. When making full-colour drawings, you can be quite literal and simply aim to match the hues.

All colours have a tonal value and some, like reds, are deceptive. They cause confusion because they are bright, not light, but you can discern this by peering through your eyelashes as before. Provided you retain the right tonal relationships between the different colours, you will be able to create the required illusion of three-dimensional space on your two-dimensional picture surface.

The curvilinear shadow shapes are a unifying factor in this design, showing how important it is to think about tone when you are choosing your composition.

Artist's Tip

'Stumps' are pencil-shaped tools of rolled or compressed paper, used for softening the marks of erasable media. They create subtle tones cleanly and accurately. Use the point or broad side to blend or spread soft or dusty deposits, or dip them into graphite, chalk or charcoal dust to draw the softest tones. Clean them with your eraser.

Proportion and Perspective

Perspective is a set of rules by which spatial recession can be depicted. You can verify all the guidelines of perspective by simply looking at your present surroundings.

Notice proportion first; whatever their real physical size, objects appear smaller at a distance. Intervening items often obscure those further away, so by simply drawing the nearer elements large and those beyond smaller, overlapped where closer objects block your view, you will give clear visual clues to distance.

Second, observe that horizontal elements above your head appear to slope downwards as they recede away from you, while those below seem to slope upwards. You must use these optical illusions throughout if your drawings are to look plausible and to show convincing representations of space.

Choosing your eye level

Raising your eye level and looking down from above will give you a wider view of a still life and the spaces between the objects too. Lowering your eye level to observe diagonally from a shallower angle will appear to condense these distances, a phenomenon known as foreshortening. The term refers to the change in proportion observed when the lengths of receding elements seen from low angles appear shorter than they are known to be in reality.

The low eye level taken in the thumbnail sketch (*below left*) and drawing of this shell, stone and driftwood arrangement (*below*) is revealed by the dramatic foreshortening of the length of the horizontal shelf. Notice that over the span of the shelf the width remains relatively unchanged; as the shelf is quite short it would be misrepresented by additional narrowing.

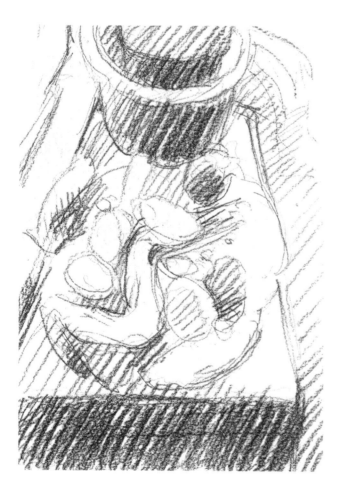

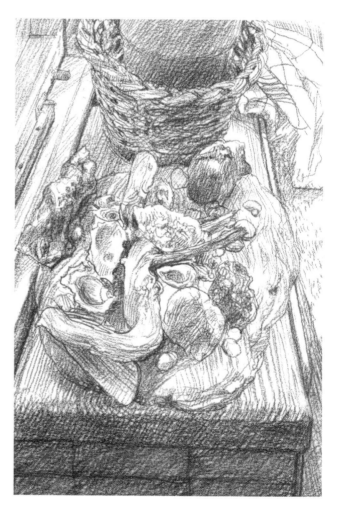

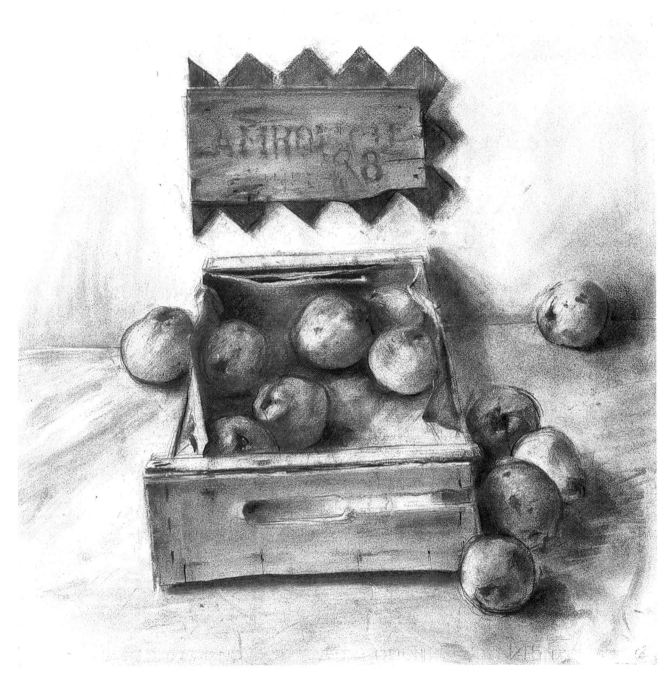

The unchanging vertical

However many angles the sides of horizontal elements in your drawing are seen to be at, anything that is vertical will always appear upright. Check to ensure that verticals have been drawn straight up and down, because if they are sloped, your objects will seem to be toppling over.

Here, several clues are apparent. The fruit at the rear appears smaller, with some pieces overlapped. Horizontals seen below eye level are sloped upwards as they recede, verticals are upright, the crate's length is foreshortened, and the width of the far end of the box is comparatively undiminished as the distance is only short.

Circular objects in perspective

Your eye level determines the way you see circular objects too. Seen from above, these look completely round. Lowering your viewpoint foreshortens the shape by decreasing the apparent length of the diameter so that you see an ellipse. The lower you go the narrower the ellipse appears, although no circular form will have sharp corners, so retain a curved perimeter at the extremes of the width, however tight the turn. Eventually, when both the object and your eye level coincide, a profile view will have some angular aspects, unless the subject is ovoid or spherical.

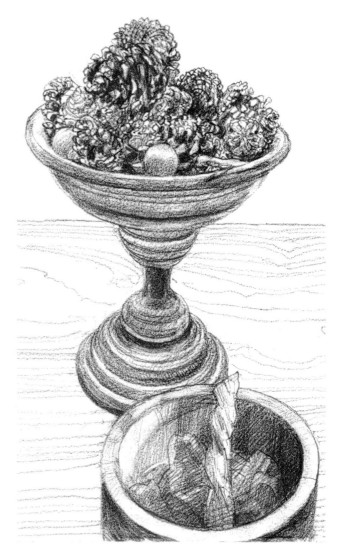

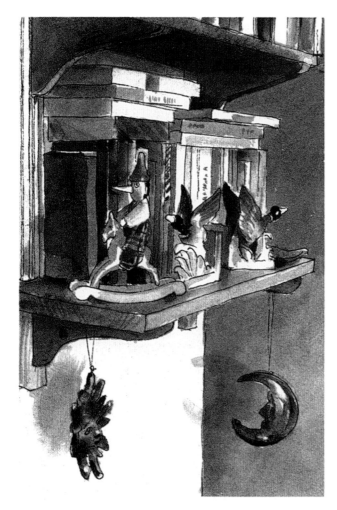

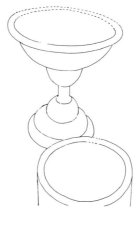

Looking down from a sharp angle shows the nearest container and the foot of the wooden chalice as broad ellipses (*above*).

Like the bookshelves, the dangling sun ornament has a foreshortened dimension, but here it is the apparent width that is reduced by perspective (*above*).

Tracing outlines reveals the chalice bowl as a narrower ellipse at the rim, where it is closer to eye level (*left*).

Multiple ellipses

The taller the circular object, the more changes in the curvature of ellipses or partial ellipses you will see from top to bottom. When seeing several together, draw those you look down on as more widely curved than those nearer to your eye level . Knowledge often impairs perception, and you may be tempted to flatten the base because you know it stands level on a surface.

If you transgress this rule of perspective you will make an image that triggers disbelief, so the final test of your drawing is a simple visual assessment to check the credibility of the curvature. Rest assured that if it looks right, it is right! Round objects only diminish in proportion to distance, but remember to draw flat planes in perspective if an item has a combination of round and flat forms.

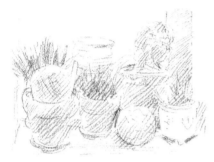

1 The first rough statement in an erasable medium establishes elements broadly to assist in assessing dimensions. Ellipses are described faintly as a first trial, ready to be amended if necessary.

2 As tone is reinforced, shapes are easier to see. Ellipses can be narrowed or curved more as required, and round forms can be corrected by additions or removals if they are not convincingly circular.

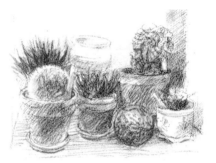

3 Adding further to tonal intensity offers the opportunity to assess the perspective and amend the relative curvature of all the circular shapes, adjusting the tonal changes across their round surfaces.

4 Remember to make a final check to confirm that flat planes are in perspective too, and that spherical shapes have the correct tonal changes to show roundness.

Patterned objects or backgrounds help to create plausibly three-dimensional drawings. Checks, stripes, patterns and even incidentals such as slatted blinds must all follow the rules of perspective, neatly describing contours, recession and the proportions of your group in the process.

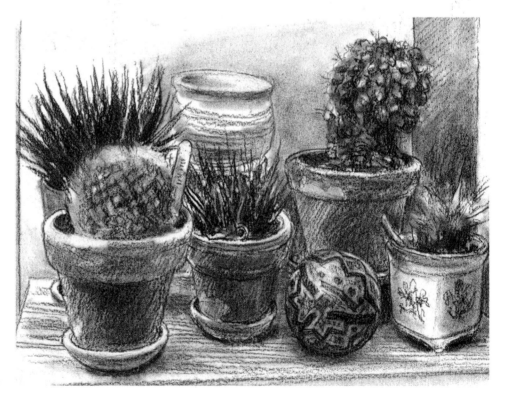

Form and Space

Make a habit of noticing the negative shapes of space between and around the solid objects in your group, and drawing them as deliberately as the positive forms. These are easily overlooked while you are focused on your group, but whether objects are complex or simple, smooth or irregular, they are seen in concert with their surroundings, and the spaces are often less difficult to capture than the solid subjects. By drawing the shapes of gaps between items you will have drawn one side of each form and will find it easier to fix the remainder with an aspect already established. In a complicated arrangement with few spaces, try using the voids of the surrounding area to determine or confirm the overall group shape. When confronted with a tricky item, clarify the area it occupies by drawing a neighbouring form or space then return to your sticking point, armed with enough clues to solve the problem.

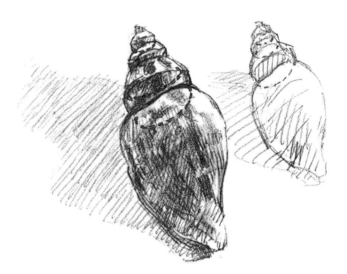

Shells can be found in a great variety of beautiful, asymmetrical shapes (*above* and *below*). Natural forms such as these are easier to draw if you consider the simpler spaces and shadow shapes between them too.

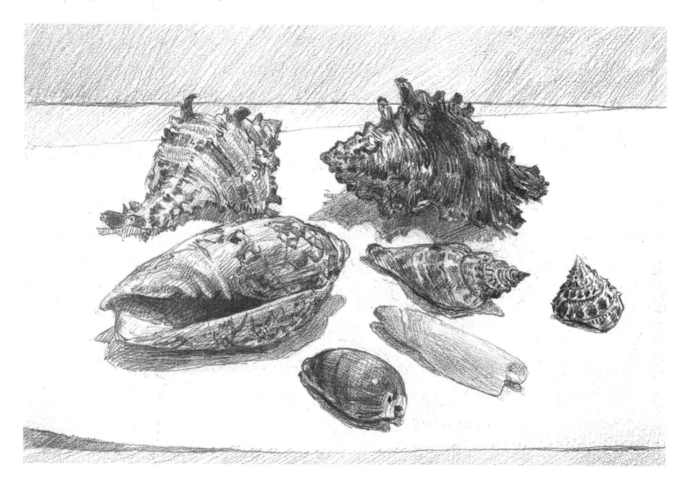

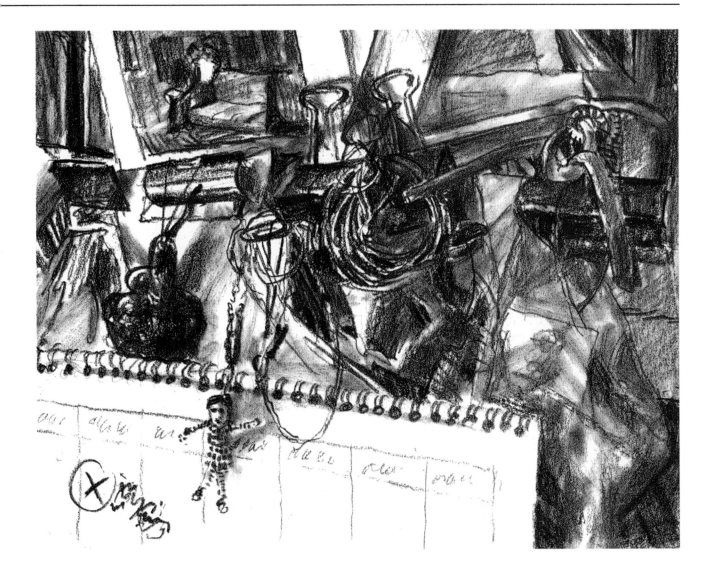

Designing in three dimensions

The area of vision in sharp focus at one time is narrowly defined, and is trained on objects in turn. However, although you focus on items separately, your vision enables you to see clearly at different depths in space. Consequently, you are able to design in three dimensions, unlike a camera, which must be focused on infinity or a distance band from which it makes an indiscriminate image. Your drawing should have a three-dimensional design as well as a two-dimensional, flat layout. This visual ability to select throughout the depth of space offers you the chance to choose which positive shapes or voids are to be the major factors in your spatial plan.

This drawing features the shallow space created between the diagonals of a spiral-bound calendar and an alignment of bulldog clips. Between these the eye is taken on circular journeys round coils of string and stopped at various memorabilia.

Choosing your spatial options

Your viewer's gaze will move through and around the illusionary picture space, drawn to different centres of attention and stopping points in the picture, and your three-dimensional design simply plans this journey. You can use the positive forms as stops and the negative spaces as avenues of vision, or harness arbitrary effects available. For example, where contours or circular forms take the eye, a dramatic light effect highlights an eye-catching form, or an alignment rushes the viewer through the drawing in an irresistible direction, encompass these positively in your spatial design.

Scale and format will influence the character of your image and three-dimensional design, but it is light which reveals form, so choose your lighting with care. You can create depth in shadow, pick out the subtleties of various surface changes or contours, and sometimes even generate reflections, depending on the surfaces of the objects. Light quality changes the perception of forms too; for example, spotlights offer stark views and candlelight soft ones. Incorporate tone into your spatial plan, and remember that distance reduces tonal intensity. Take this into account if you include a distant view beyond the subject.

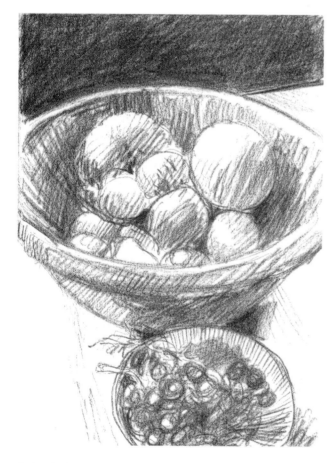

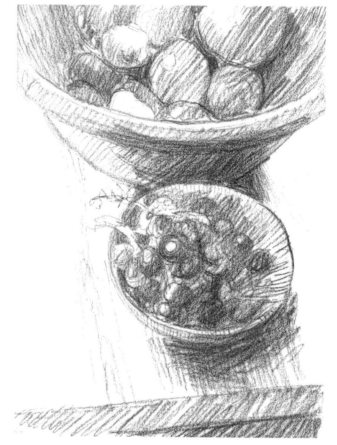

1 Simple forms and spaces have an immediate impact and may convey grandeur or vastness, although domestic in scale. The viewer will look more slowly at complexities, taking in intricacies.

2 Choosing where to cut both the positive forms and negative spaces determines the pace and character of the three-dimensional design, offering different effects by simplifying or expanding the visual perambulations around the picture space.

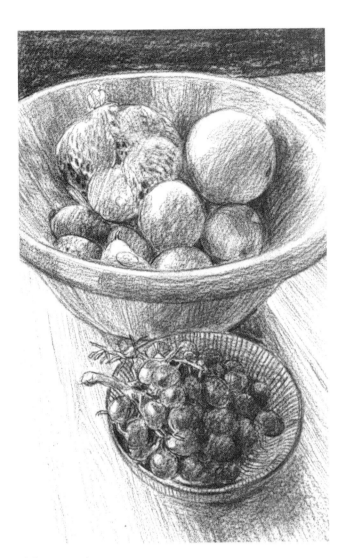

Group dynamics

Take group dynamics into account when drawing form and space. Aside from the group shape that your forms will make, and the combined spatial depths visible through and around them, you can emphasize or negate qualities and characteristics in your three-dimensional design by the way you juxtapose, complement or repeat the shapes of forms and spaces. Contrast plays an important role too; see how a rounded group benefits from some angular elements to break the circular movements, or a design dominated by dark forms appears more dramatic when shown against brilliantly lit space.

The everyday character of the kitchen scales is enlivened when a pyramid of circular weights creates an eye-catching spatial entity and a contrasting, asymmetrical plant form weighs in the balance.

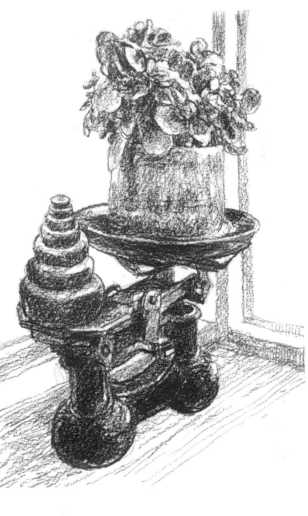

3 Repeating forms or similarly shaped spaces will lend emphasis to a design. Here, showing the two bowls and their contents adjacent to each other generates interest by juxtaposing two echoing but different elements (*above*).

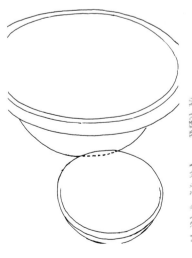

The edgy spatial relationship between the forms exists because a tiny overlap barely keeps the looming, larger bowl behind the smaller (*right*).

Pattern and Texture

Pattern and texture, whether they are natural or manufactured, attract interest for the decorative value and visual excitement they bring. Take care not to have too much of a good thing; a group composed only of patterned or textured items is the visual equivalent of a tune played on the piano with the loud pedal down all the time, calling attention in an uncomfortable way! A thoughtful choice will serve you better, so try various combinations of patterns and plain and rough textures and smooth surfaces until you get the right mixture to show off the decorative features. This way the viewer's attention will linger to enjoy your selection at leisure.

Pattern and texture are good workhorses, too. By following the contours of objects, pattern reinforces the three-dimensional image, and texture gives a clear sensation of feel and substance, adding to the drawing's plausibility. Lighting, by shadowing or highlighting effects, can alter both. If they are made dominant visual qualities your drawing may assume an abstract identity, although drawn from observation.

You can alter perception of scale by using pattern and texture effects. Here, even though they are small, the winter squash and dish take on a flamboyant identity because the contrast between random and formal patterns is the most striking feature of the drawing.

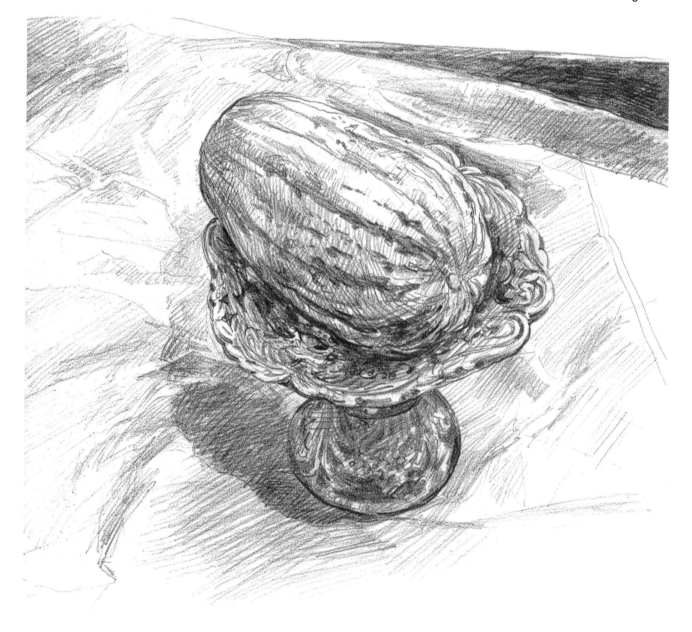

Here I had some fun drawing ducks; fabric feather patterns echo glossy china feathers and, between them, a string vegetable holder recalls the textures of a nest of eggs.

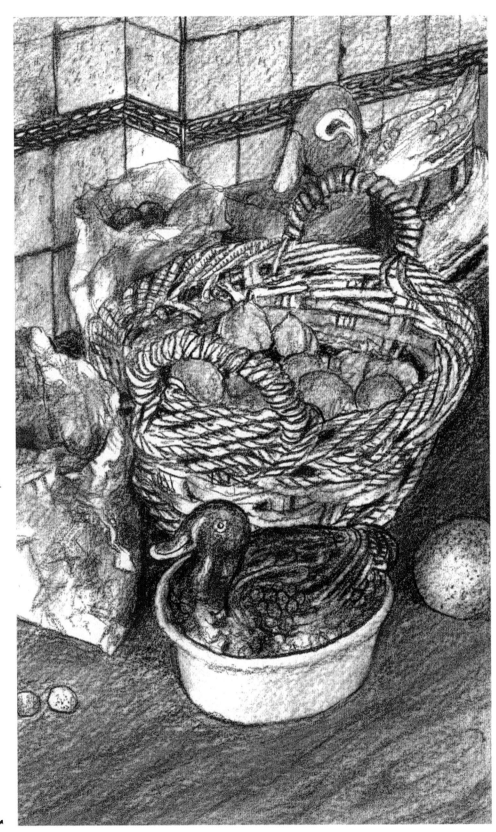

Artist's Tip

Drawing complex patterns or textures is laborious and time-consuming, even if you enjoy tasks requiring patience. Some short cuts will make the drawing look as if you have done more than is the case, such as textures derived from paper surfaces or acquired by frottage (rubbing found textures). Where appropriate, draw unobtrusive patterns freely, and add detail only in key places.

Introducing pattern and texture

Timing the introduction of pattern and texture effects needs consideration. When light creates beautiful random patterns and textures they will change rapidly and must be caught quickly. Fix effects opportunistically, then leave well alone. However, where patterns and textures are constant you can develop them at leisure. Manufactured patterns and heavy textures with a repeat lose credibility if this is not followed. Include the whole extent in a simplified version from the start. Repeating patterns are eye-catching, and should be a constant factor in your calculations; steady development throughout ensures that the final effect fits properly with other values. Faint or subtle textures and tiny details of pattern need only be hinted at until you have created enough structure to guarantee they are accurately placed.

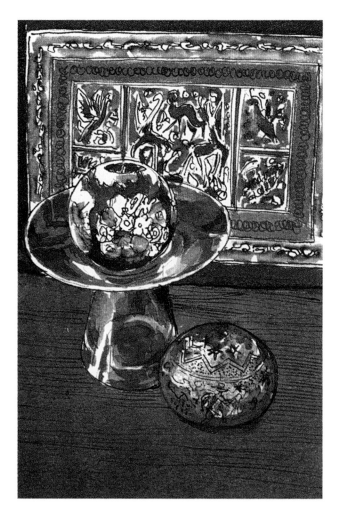

I established the patterns of glass and hand-made objects gradually, using brushed ink (*left*). This type is soluble when wet, so I drew details lightly then washed them in.

Here I drew the pattern effects of leaf fans, a floral urn and repeating wallpaper in erasable carbon pencil, developing them evenly from the start (*top* and *above*).

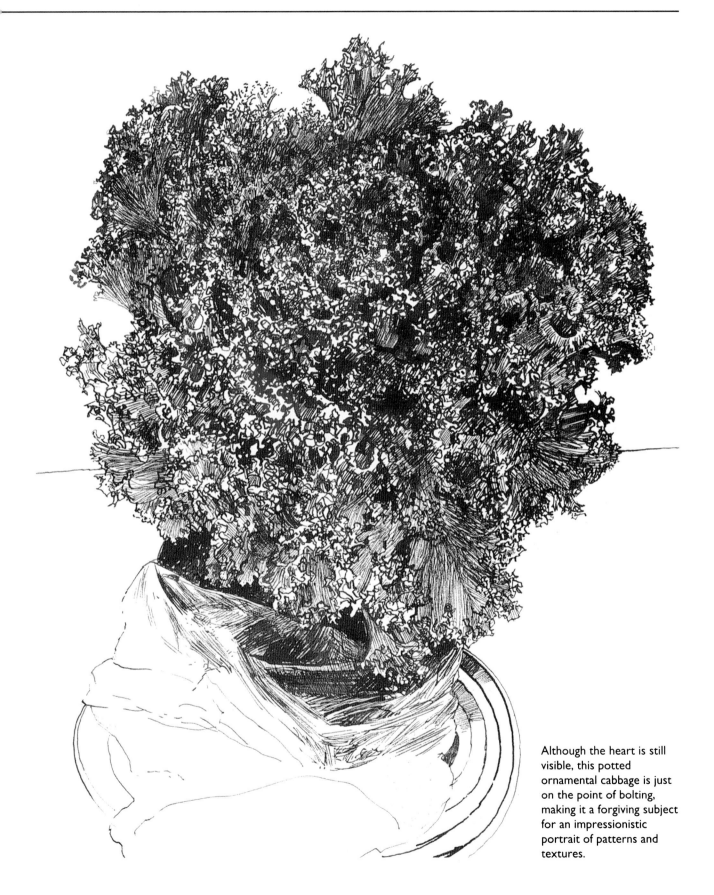

Although the heart is still visible, this potted ornamental cabbage is just on the point of bolting, making it a forgiving subject for an impressionistic portrait of patterns and textures.

Specific Surfaces

Fabric

Observation is the basis of success in drawing the variety of fabrics you are likely to encounter, which will present many different qualities. As with any practical task, drawing benefits from an initial speculative pause. First, assess the characteristics of the material, then determine how to go about it. Is it soft or crisp, smooth or crumpled, shiny or dull? Examine the tonal transitions carefully; their nuances must be captured to convey the fabric surface you want to show. Study the cloth to see if a pile such as that of velvet is softening the fall of light to reduce tonal contrasts across the spread, or if a satin finish is creating a gleam that contrasts sharply with shadows. On firm, substantial fabrics with heavy folds, expect strong shadow values, while on fine material with shallow folds or puckers the tonal changes will be slighter. Remember to keep patterns in perspective, too.

The polished cotton on which the pocket games are strewn is a light cloth, lying naturally in crisp, fine folds (*below*). The surface sheen reflects and bounces light from the raised areas of fabric, and the cast shadows appear deep by contrast (*see detail above*). Notice that the folds follow the perspective of the underlying table, too.

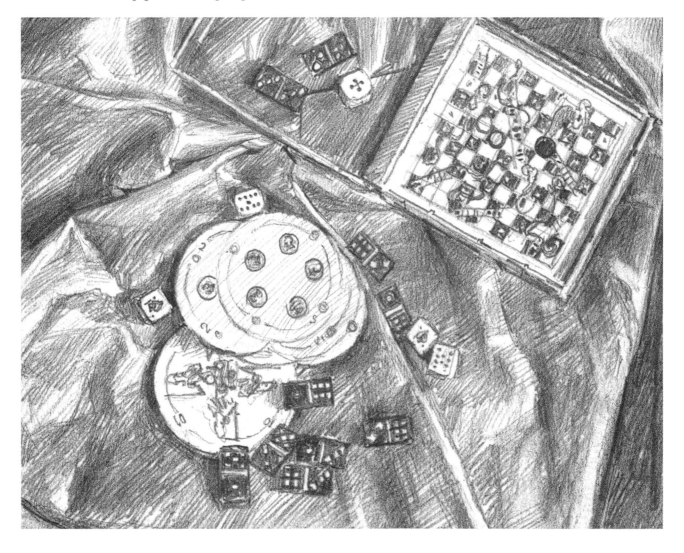

Metal

Dull metallic finishes and rusty metal are simple to draw, having a bloom rather than a shiny surface. It is polished metal, stainless steel and chrome that you will have to look at more carefully. Notice that the tonal relationships are polarized, with brilliant highlights and rich, strong darks. Be prepared to draw in relatively deeper tones throughout the surrounding area to give full brilliance to the highlights.

On cylindrical or circular forms, the surface on the unlit side may reflect surrounding pale objects or secondary light sources, reducing the depth of shadows, especially towards the edges of the curves. When glossy surfaces reflect other items in your group, remember that the reflection will conform to the shape of the metal, producing distortions like those in a fairground hall of mirrors.

Reflective and non-reflective surfaces are shown here *(below)*. The convex surface of the stainless steel sifter *(see detail above)* gives back a narrowed reflection of the surroundings. The tonal values of the reflection are darker, with the metal acting like a tinted mirror. The fine mesh top is almost imperceptible.

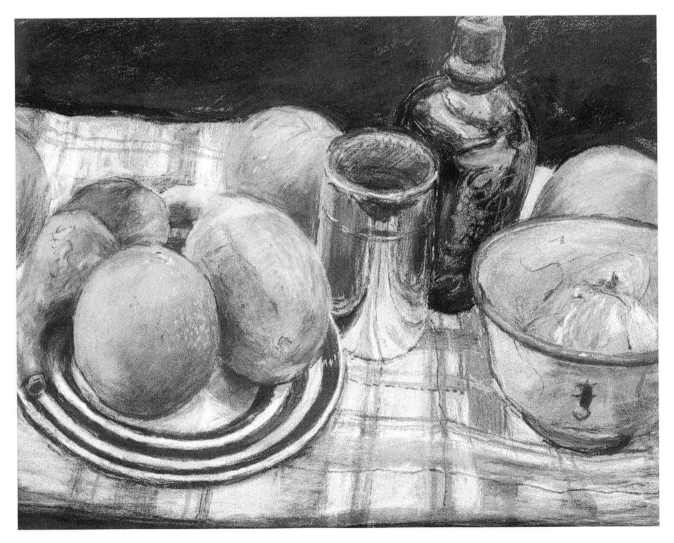

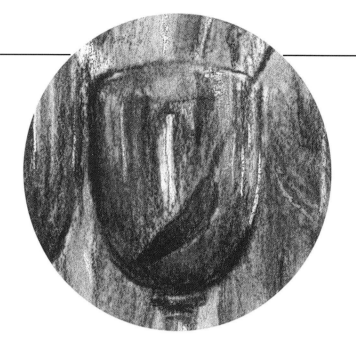

Glass

While you are drawing the broad proportions in perspective, determine the areas of the three possible appearances of glass you need to represent. Looking straight through the glass, you will see a distorted view of the reality beyond, or the flowers, sweets, glass marbles and so on within if it holds something. This will be coloured or darkened by whatever tint the glass possesses. Next, the colour of the glass condensed by the turn of the form is apparent at the sides, where nothing will be seen through the telescoped thickness. Even colourless glass can appear much darker than you might expect here. Also blocking your view and reflected on the surface are the brilliant highlights showing the light source, your lamp or window, perhaps distorted to a dot or dash by the shape of the glass, and possibly a pale reflection of the surroundings.

I drew the wineglasses on the kitchen shelf freely in order to gauge them against each other and the spaces between (*below*). Some necessary corrections left dark tones that could not be erased where highlights were needed, so I heightened those areas with white gouache applied with a brush (*see detail above*).

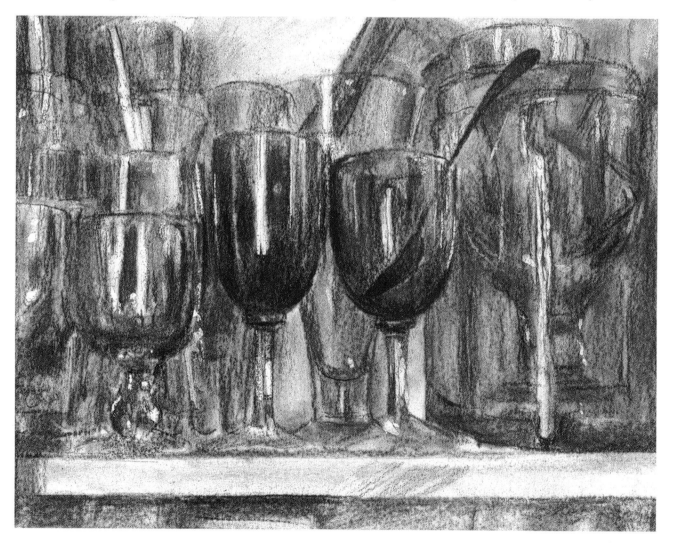

Wood

Modern wood finishes trap the surface under gleaming coats that mask the grain, but show reflections or brilliant lights in the gloss to add sparkle to your tonal scheme. If you draw scrubbed, oiled or waxed wooden surfaces or items, the decorative quality of wood grain can be conveyed by linear drawing tools. A flexible medium such as a graphite stick enables you to vary your stroke width to suggest an irregular character, and brush drawing will give you the same flexibility with the advantage of graded tone for shaded grains. Lightly polished wooden surfaces have a gentler gleam than glass or metal, characterized by less brilliance and some softer edges to the highlights, easily captured by softening charcoal with a stump. Natural forms of wood-like plant material such as nuts and pinecones have the most delicate sheen of all, suited to fine pencil.

Here I used a soft-grade graphite stick for scrubbed pine, polished lime wood and the faint gleam of walnuts and hazels *(below)*. The freely drawn marks describing the pine table are not a meticulous rendering of the grain but were a quick way of showing the surface appearance *(see detail above)*.

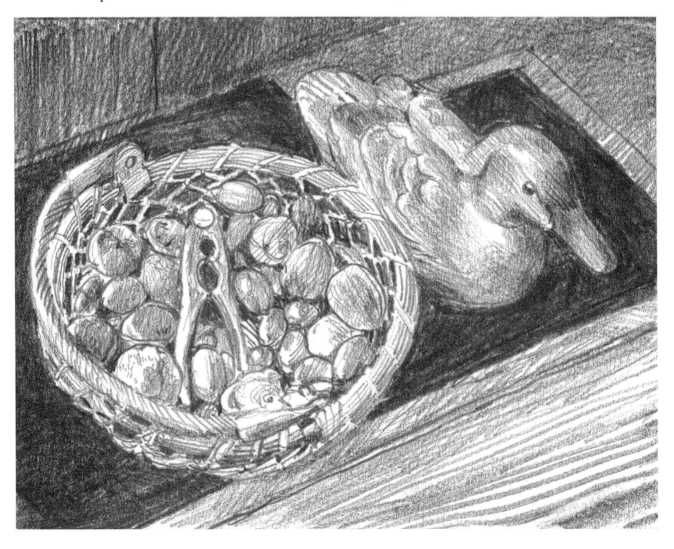

Visual Characteristics

If you are faced with unknown strangers at a social occasion, your experience of making visual selections will lead you to make contact with a person or group whose appearance appeals to you. No greater skill is needed for choosing a still life that has aspects you are drawn to, and working with preferred characteristics is the best start to expanding your skill at drawing different qualities. Your home and wardrobe will remind you of your preferences. An enjoyment of smooth, sparkling things may be revealed if your favourite possessions are glass, or perhaps tweeds show a taste for rough, matt textures.

Choosing for abstract characteristics

Although objects have a number of visual characteristics, the dominant one is the one you notice first. Let your choice for groupings fall on abstract attributions sometimes. These qualities are encountered so often in many forms that you can never have too much practice at them. You could select on the basis of forms, such as plump or angular items, or how they feel – soft or solid, slack or taut – or because of the surface appearance, with shiny or dull, rough or smooth coming into play. Include some contrast; several hard objects look firmer with something soft, or a sharp point will set off round shapes.

Developing representational skills

Finding a medium and appropriate marks to equate visual characteristics becomes easier rapidly, as you build on your previous experiences. Try similar surfaces; drawing qualities that resemble some you have tackled already mean that you are not a complete beginner, even with a new characteristic. As you gain in skill, assemble more complex combinations, with several different effects to represent together. Aim to become accomplished at drawing as many visual qualities as possible. You will gain confidence, make your drawings more credible and enjoyable, and prepare yourself for the day when you have something exceptional to record, which drawing will fix in your memory.

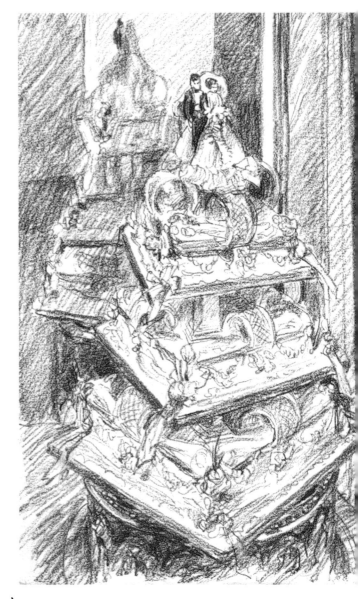

Artist's Tip

Drawing the paraphernalia associated with favourite occasions or a special event can team up interesting, unusual visual characteristics. By drawing them, you will recall the trappings of the occasion more clearly than if you had photographed them.

A wedding in the family is an occasion to remember by drawing the cake (*above*), combining brilliant fancy icing, the spiral perspective of staggered tiers and the glitter of silver trimmings.

Clear lemon tea and crisp biscuits are on the menu in this wash drawing. The decorative Russian china and painted boxes evoke far-off tea times, adding an exotic element (*right*).

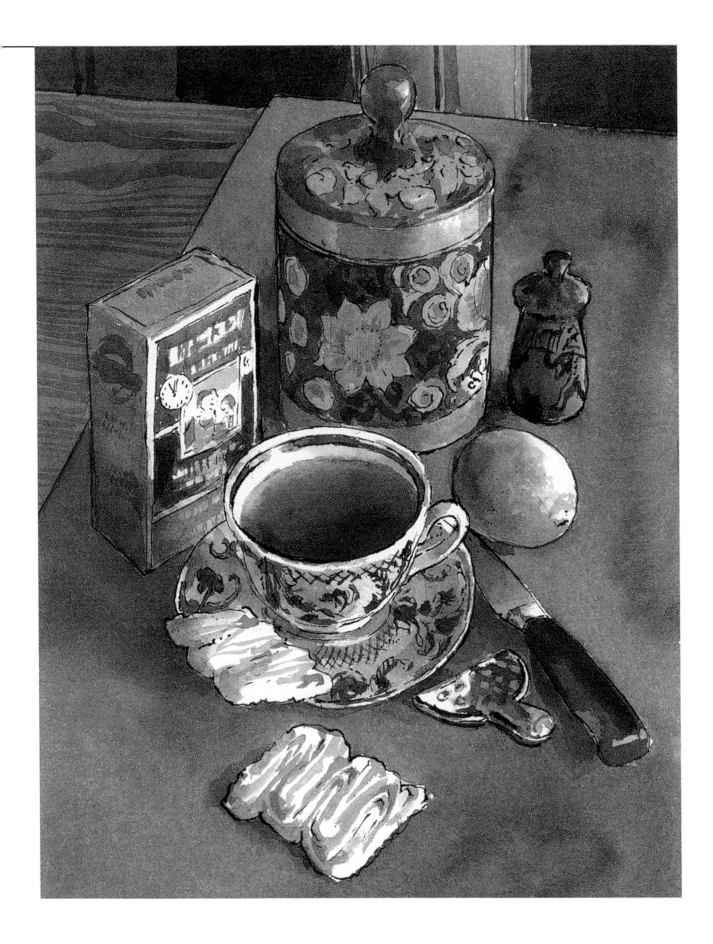

Combining characteristics

Substances such as plastic, polythene and polystyrene are the stuff of modern life, and have their own textures and appearances to be recorded by contemporary artists. By ignoring them, you would be out of step with the times just as surely as if you still used only oil lamps, so try putting together combinations of natural and manufactured items. For example, the brash artificiality of a plastic lemon will be an interesting visual characteristic if it is grouped together with some fresh lemons. Consider similar but different combinations, such as objects seen through a glass jar beside others glimpsed through a plastic bag. The juxtaposition will offer the chance to make a comparison between the subtly different qualities of their transparency.

Moulded or machined forms have very different characteristics from natural forms. Ready-made combinations are easy to find, for example fruit or vegetables shrink-wrapped on a plastic tray, or eggs in a polystyrene box. Choose the scale and format options that make the best image of the combination in hand, even if this calls for a special effort to draw oversize or use unusual media. Working on the outside edge of your technical capacity to represent new visual characteristics is the best way of increasing your repertoire and strengthening your drawing skills.

A kitchen table combination of wood, fabric, pottery, paper and natural forms has a classic look achieved by using natural daylight. Closer inspection reveals the manufactured form of an egg box, bringing a contrasting 20th-century element to the group.

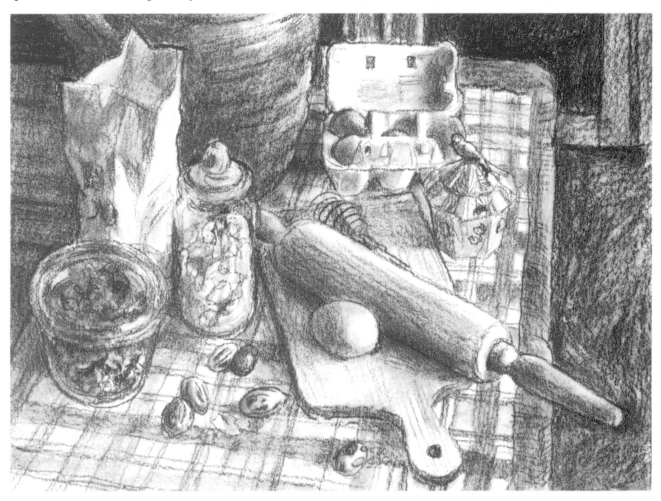

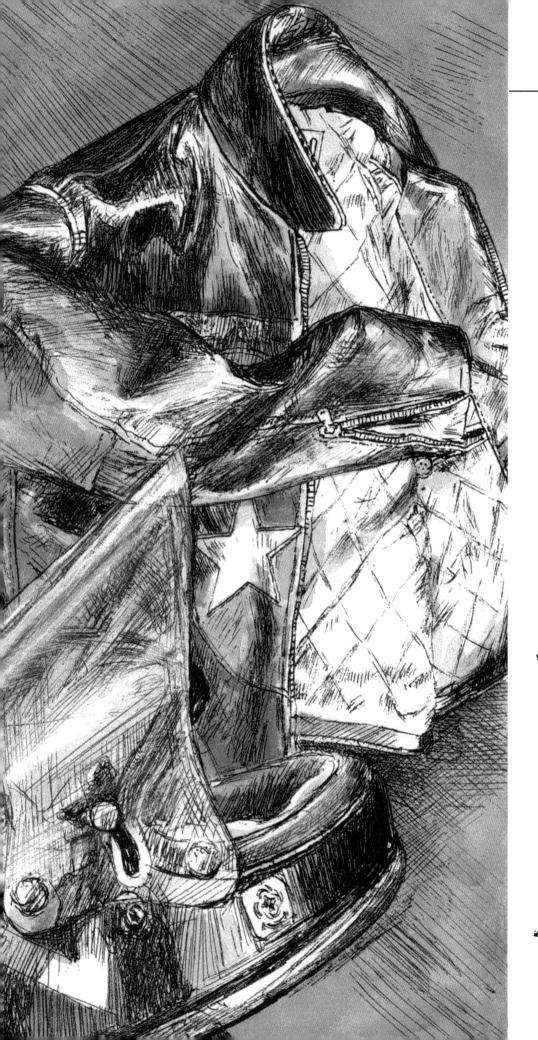

Motor cyclist's clothing
combines glossy hide with
shiny acrylic linings and the
sheen on hard plastic, and
shows the random folds in
heavy leather against an
ovoid, mould-made helmet.

Artist's Tip

*Never restrict yourself to
one medium or technique
on purist grounds if
combining two or more
can help you to reach the
best solution to a drawing
problem. Lateral thinking
may sometimes be
needed to devise winning
mixtures that represent
particular characteristics,
but provided you produce
the desired effect,
anything goes!*

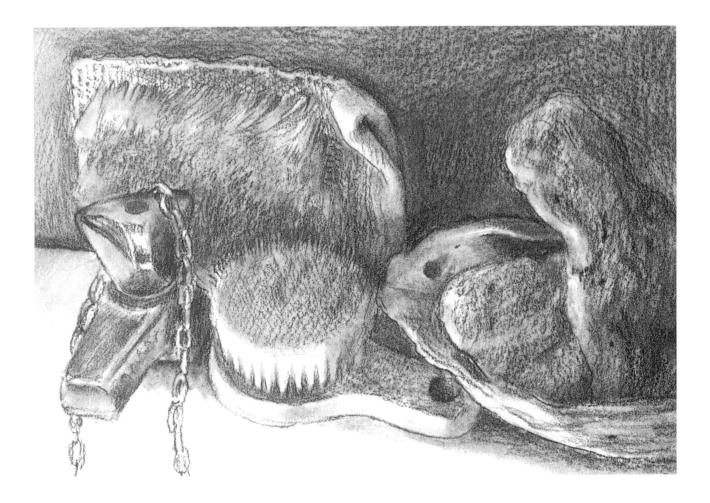

Using visual characteristics for cohesion

Part of the endless fascination of drawing is the need to organize disparate elements. You can develop your management skills while studying visual characteristics through making links between the qualities themselves. Try echoing an aspect such as the smoothness of polished wood and glass in different forms throughout the drawing, or creating the majority of the image from various items made of the same material. Strong pattern and textural qualities or repeated similar patterns and textures can unify, and characteristics of form can strengthen your design when they are reiterated in different ways throughout. If the visual qualities required for cohesion have not been deliberately chosen because your subject is haphazard, be sure to search out any links that exist between forms, surfaces, tones and motifs.

The barely perceptible sheen of unpolished wood, string and bristles is flanked by the gloss of chrome, and the echoing forms of a shell soap dish and sponge.

Lighting has an important role to play, as it possesses the ability to mask or highlight visual characteristics, or unite an arrangement bathed in a particular quality of light. The tonal qualities created by lighting or inherent in the objects themselves must be counted in your equation too. Richness or brilliance are obvious factors, but remember to take account of blandness, especially if you are working in monotone. Colour characteristics will be recorded as tonal changes only, perhaps leaving a close-toned area where you see lively hues. The combined impact of moderate qualities is a considerable factor in determining the characteristics of the drawing as a whole.

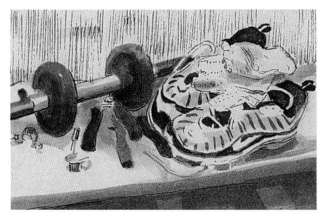

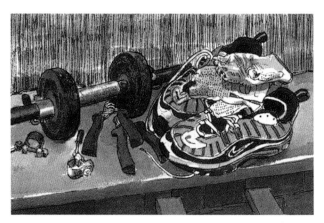

1 The stark metallic character of weight-training equipment is softened by background blinds and enlivened by patterned running shoes, all washed in faintly to check for tonal qualities and balance.

2 The close-toned quality of the diffused light and the plain shelf between the pattern of bricks and rattan unify this idiosyncratic assortment with only a sports and fitness element in common.

In this totally plastic group (*below*), the variety of characteristics is in scale, shapes, tones and different reflective qualities, together with an angular view and the contrast that is provided by the various curvilinear artefacts.

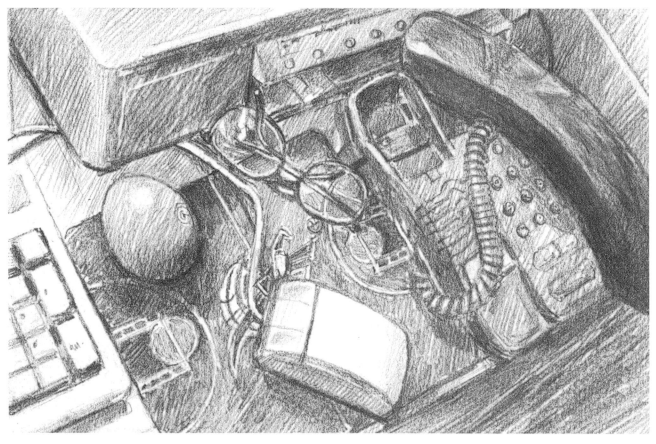

Interpretation and Evaluation

An indiscriminate blanket approach to drawing is the usual path for beginners, but plenty of practice will bring increased competence sooner than you might expect. Once you are beyond struggling to create a simple, recognizable still life you have made progress. As your drawing ability improves even a little, you must decide how to develop your new skill. Acquiring more technical polish alone leads to hollow triumphs, with technique more noticeable than content.

Balance the need for an effective manner of drawing with a personal interpretation of the subject, and keep the qualities you choose to convey as your priority, not the drawing method you devise to portray them. You can determine your interpretative intentions as you select and assemble items, adjusting both if necessary when you see the overall appearance, or decide spontaneously when you discover a random group, but have the courage of your convictions. The range of possibilities is as large as the number of subjects and artists, and each is valid, being the unique reaction of an individual to a particular vision.

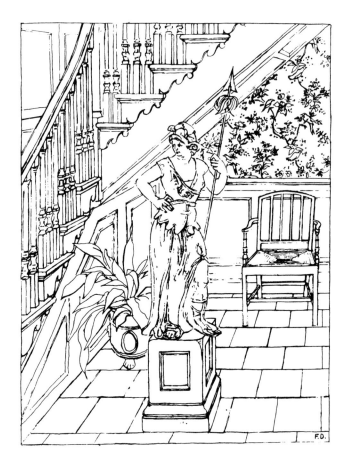

This decoratively patterned linear approach masks a mathematical grip on proportion and perspective, with a dynamic impetus from vigorous diagonals positioned to take the eye through the picture plane asymmetrically (*above*).

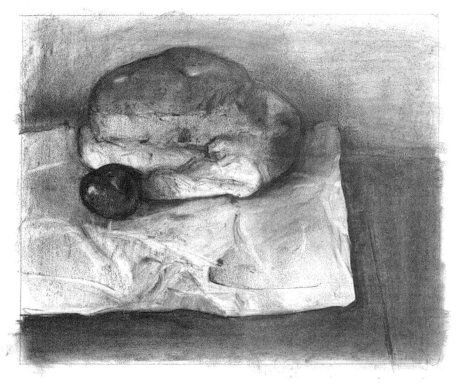

The expressive use of charcoal conveys the beauty of light in this interpretation, using only the essential tonal elements to create a strong and simple image of a daily staple (*left*).

Identifying your interpretative style
You have an artistic identity just as you have a basic personality, and the two are not necessarily identical characters. For example, brash people can produce timid drawings, and sweet natures may make strident ones. Initially, your interpretation may be coloured by natural tendencies in addition to your intentions.

Once you recognize your natural style you can settle down happily to produce drawings with your personal stamp whatever the subject, or try extending your range by deliberately arranging groups that call for other approaches. Try fine linear media and delicate subjects if you draw strongly, or charcoal sticks and rich subjects if you are tentative.

1

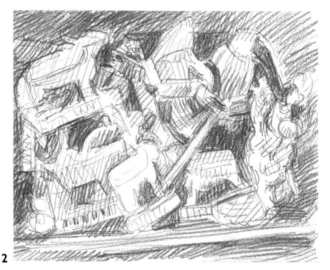

2

1 This collection of Asian toys in a shallow box called for a strong interpretation, requiring some underlying organization so that it would not appear jumbled. First I made a linear plan of the flat, pattern layout (*above*).

2 Looking at the tonal scheme to check for strength is helpful too. The toys were painted in bright reds that appear as dark tones in a monotone drawing, so I plotted out their position (*above right*).

3 I used vigorous charcoal strokes to depict both the ebullient characters of the toy animals and their bright gleam from the deeply shadowed box, and drew the hand-painted decoration freely (*right*).

3

Timing your interpretation

The time available and the durability of the group will influence your interpretation. There are strategies you can try if there is a discrepancy between your intentions and the group life, for example in decorative interpretations of floral groups. These may need to be refreshed with second and third bunches of the same flower variety, or even left until next year if you want to relate every delicate stripe and petal curl in fine media. Replacements will not match exactly, but will be similar enough for you to continue a sustained drawing. Mark the positions of durable items wherever possible if you have to pack away between sessions.

For a necessarily rapid decorative interpretation, for example if you are drawing fish on a warm day, try brush drawing to capture every speckle and bar before they become unpleasant company and save yourself the trouble of searching for others. For moving subjects, such as tropical fishes in a tank, make numerous sketches in any rapid media, recording what you can, then edit the information from all your scraps into a composite interpretation of your choice.

The interesting aspects of this random group were the sinuous directional movements originating from the oil can and tilting plant holders, contrasted with cylindrical forms. The rapid, free interpretation minimizes other items by developing them less intensively.

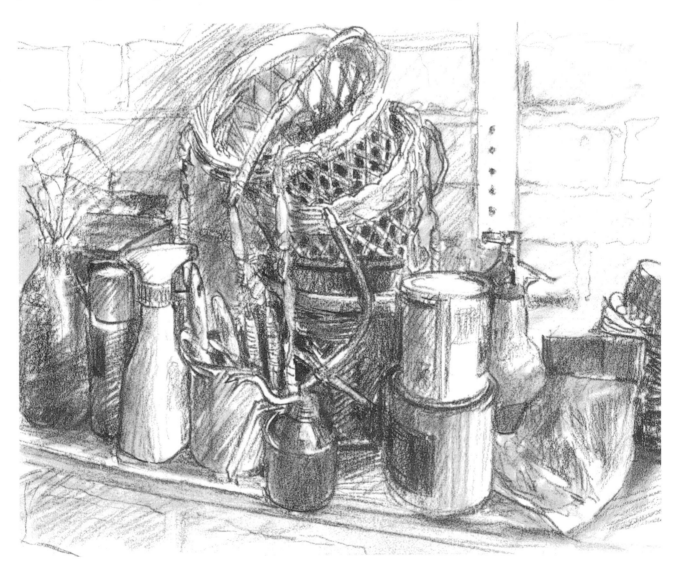

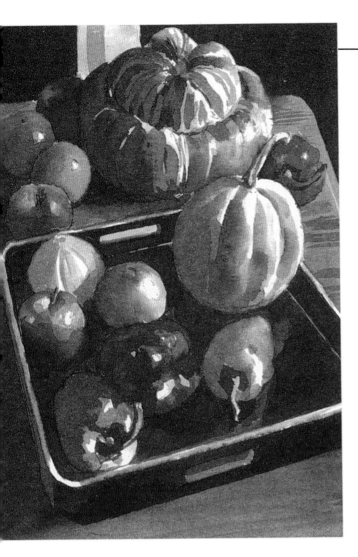

Evaluating your image

It is not possible nor desirable to draw all the visual qualities on view with the indiscriminate detail of a photograph. Personal selections are required in interpretations, choosing some aspects for attention and giving less importance to others, just as the modulations of an actor's voice lend colour to a role. However, the physical act of working on a drawing necessarily develops aspects sequentially, and even when you make an effort to advance the whole image evenly some elements will be overemphasized or neglected in the process. You need to evaluate the development continuously to keep it in line with your creative intentions. When standing back from your drawing to compare your image with your subject for accuracy, notice discrepancies in emphasis or understated elements too and redress the balance.

Interpretations record time in many ways; this travel group in a dark hallway recalls the peaceful stillness of a homecoming after a long journey (*below*).

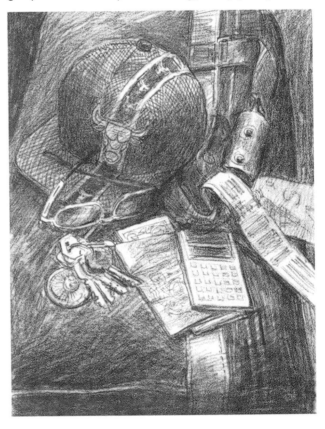

This rapidly made, lucid interpretation of perishable vegetables capitalized on the speed with which ink can convey subtle tonal transitions (*above*).

Although non-waterproof ink is sometimes partially removable, building up tonal strength gradually is faster than trying to wash out excesses (*below*).

In Setting

The day will arrive when a natural still life takes your eye in the garden or beyond. If they do notice you drawing most passersby will pay it little account, and provided you are in a safe location and dressed appropriately for the weather, some real fun is to be had from the range of subjects beyond the confines of home. A portable drawing kit is easy to assemble in an old box or satchel, but a pad, pencil and rubber are enough to capture anything you come across, so be sure to carry a pocket sketchbook all the time. By responding to anything you come across, you will increase your flexibility and versatility.

If the setting for your spontaneous grouping is your own garden home comforts will be to hand, but further afield consider carrying provisions and a lightweight camping stool to extend working time. For holiday drawings, clean, lightweight, versatile materials such as coloured pencils will always earn their place in your suitcase, and a technical pencil with drawing leads weighs no more than your toothbrush.

Ornamental garden furniture and bricks combine well with plants for an elegant linear outdoor still life. Going over a pencil plan later in ink easily becomes stale; try drawing in very fine ink lines first to allow stronger corrections.

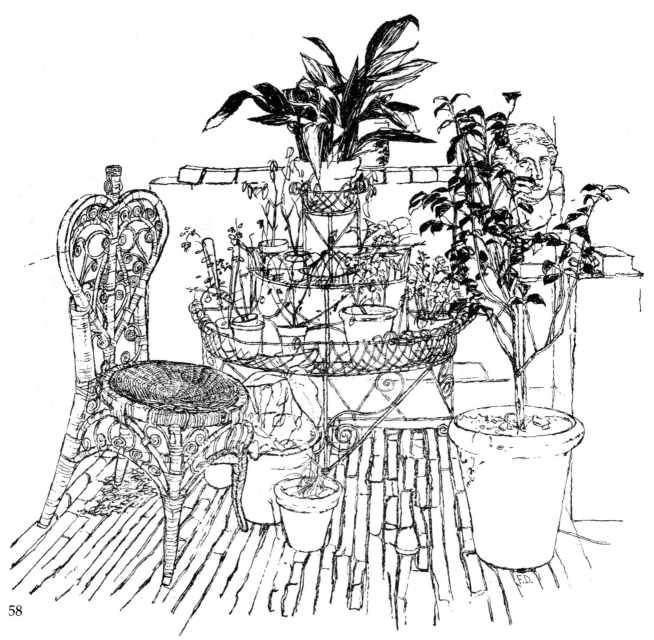

Night eclipses the garden,
but a terrace candle is a
still life itself. Remember
that to show brilliance
other values need
darkening, and notice the
dark halo surrounding the
flame (*above*).

A location drawing of
overgrown Victoriana
picked out by sunlight in a
quiet cemetery makes a
contemplative group,
with the elements of
transient beauty found in
a traditional memento
mori (*right*).

Working from Reference

Many factors, such as a downpour or a train that won't wait, can cut short location drawing. Even on your own balcony, the changing light may bring you to a full stop. If interruptions leave you with several unfinished drawings, or you have a sketchbook full of interesting snippets, there is a case for working from reference. This time-honoured practice can be used to create finished drawings from sketches made from observation, and is also useful for still life groups containing changeable items.

The content is the priority for the preliminary drawings. They may be handsome in their own right, but most importantly they should be packed with information to sustain you while working from them. If you lack finishing time, try to bring small, complex areas up to full detail, so that you have clear examples of the intended final appearance. Resist the temptation to work on preliminary drawings later. They are a true record of your observations, and by continuing from memory you will bury the evidence. Make your finished drawing a starting point from which to develop things further – you can always begin again as long as your reference material is still intact.

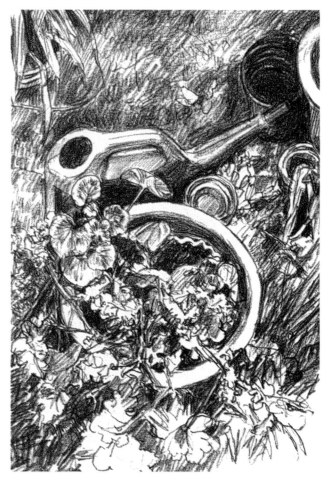

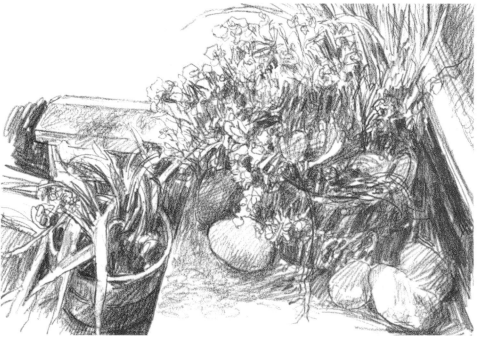

Plant pots and a watering can are a self-contained study for development, or could be foreground material for a composite garden still life (*above*).

Plants and stones on steps could be combined as a foreground still life with a landscape view beyond, or as the background study for nearer objects (*left*).

Drawing form and volume such as these receding steps is essential to organize your two- and three-dimensional design. However cursory your preliminary drawing, make sure you include enough spatial information (*right*).

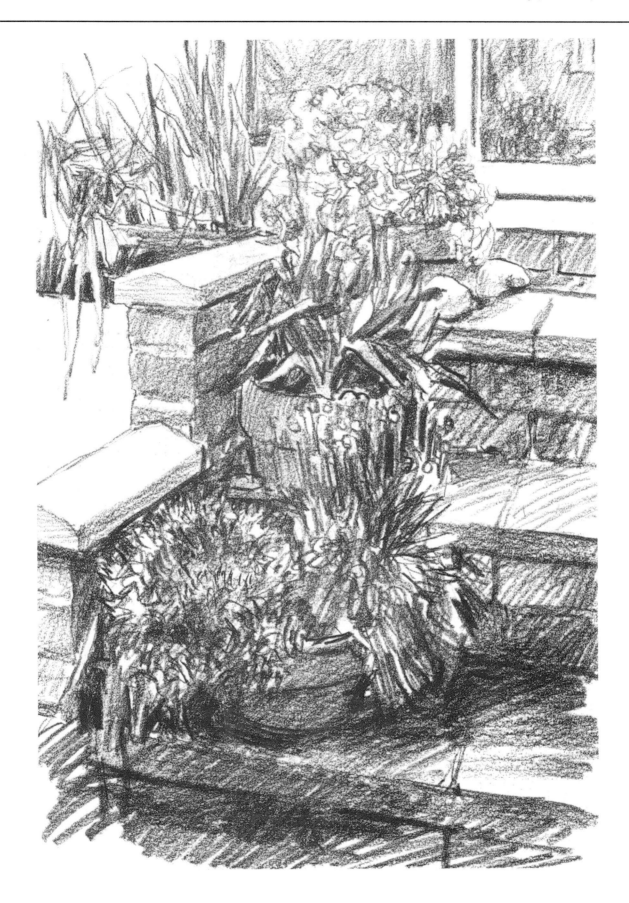

Illusory combinations

Remember that when drawing first-hand you should include everything within your chosen format. Ignoring what you see in reality is difficult, while invention will be required to fill gaps with imaginary objects or backgrounds which are unlikely to be convincing.

However, you can easily edit elements from a credible record of still life in one place at one time and combine them with others made in another time and place. The information you are dealing with at this point is already two-dimensional, and you are simply marrying two illusions – or more, if you combine several drawings. If you enjoy working in this way, you can create groups amid scenes that have never existed together, but which convey veracity because their source material was well observed.

Squaring up drawings

If you have a true eye for proportion you may be able to transpose elements together directly, but squaring up drawings makes the task easier. On your original, mark out a square grid by measuring points equidistant along both dimensions, joined with ruler lines. Count the squares and part squares along each axis, then create a matching grid on your new paper surface. Vary the size if you prefer by using larger or smaller paper of the same proportions. Mark out the same square total exactly, numbered for reference if necessary, and the squares will show where to locate elements in the new drawing.

With luck contributory drawings will be on compatible scales, but more often you will find a discrepancy, so that literal transpositions will not conform to the rules of perspective concerning recession, in which distance reduces size. You can rectify this by keeping to the same square total, regardless of their sizes, for each contributory drawing used at the same apparent distance in the new work. To reduce a scale for remote items in your drawing decrease the number of squares; increase them to enlarge

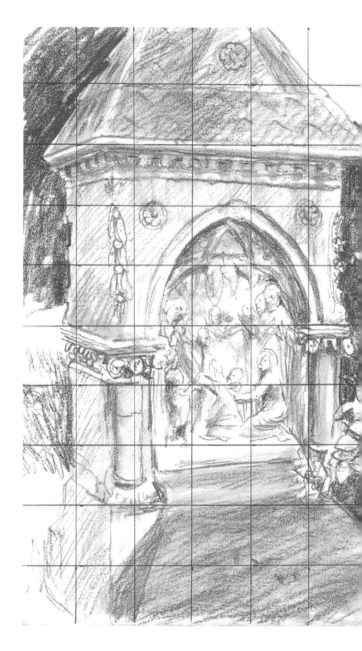

This curious memorial (*above*), with an intricate low relief carving and the spreading shape of the base echoing that of the roof, has sufficient interest to be included as a background study for a composition.

scale for objects in close proximity. To preserve your reference drawings for other use, mark out the grids in spirit pen on removable transparent film taped over them.

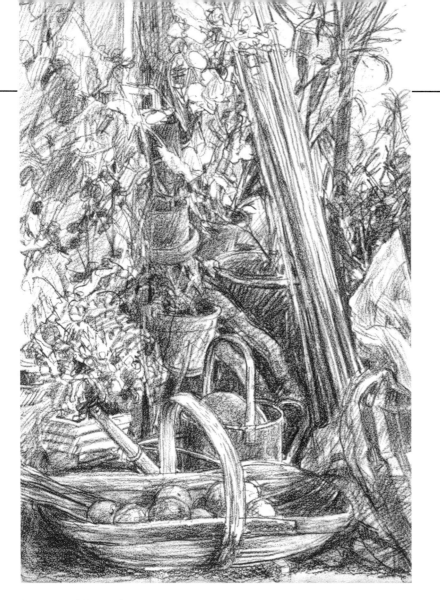

Artist's Tip

Sort your reference drawings for possible composite work carefully in advance, and group together drawings made in similar weather and light conditions. Pay particular attention to light direction; normalizing discrepancies is a difficult task to be avoided, and leaving apparently conflicting light sources uncorrected robs your final drawing of credibility.

A corner of the garden (*above*), crowded with plants, bags, canes and a trug, makes a busy preliminary study that will be improved by editing out some of the untidy clutter beyond the canes before using it in a composition.

The sketch plan for the composite drawing. Omitting fringe elements from the garden still life and tailoring it to intrude across the monument sketch creates a garden with a Victorian Gothic feature, or perhaps the illusion that the cluttered corner is in the garden of a mansion (*right*).

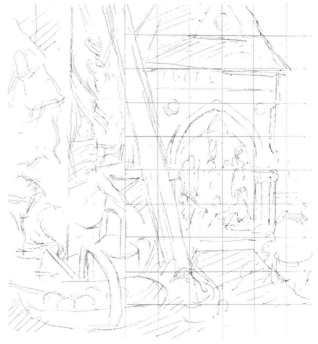

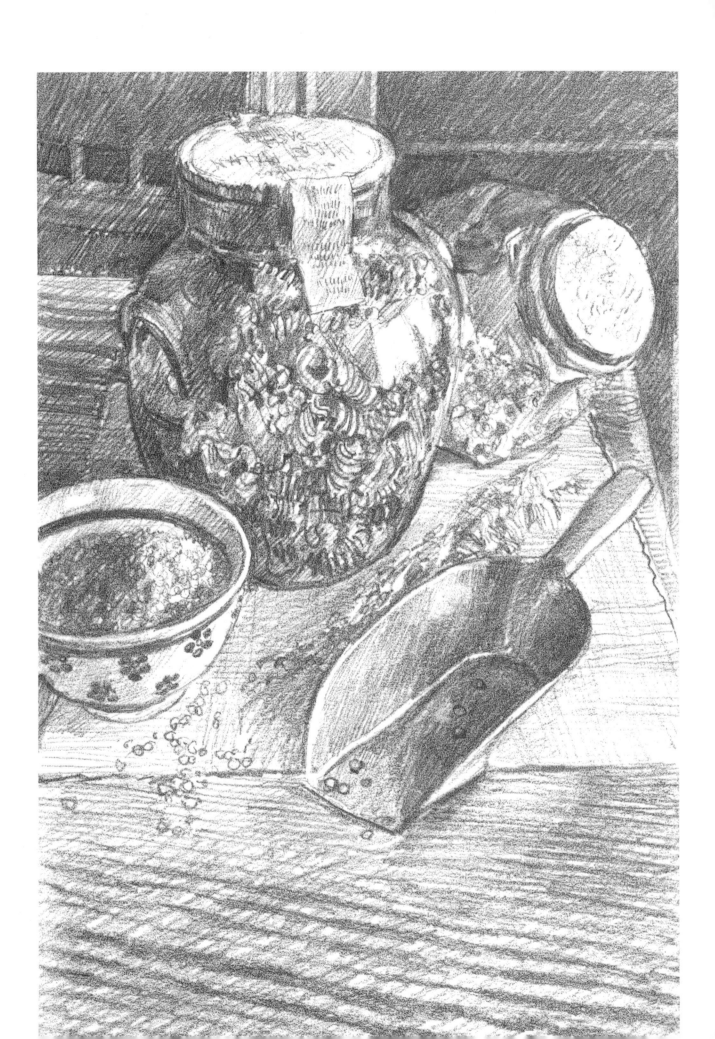